Indian Drawings and Painted Sketches

Asia House Gallery, New York City

Fogg Art Museum, Cambridge

Asian Art Museum of San Francisco;
The Avery Brundage Collection

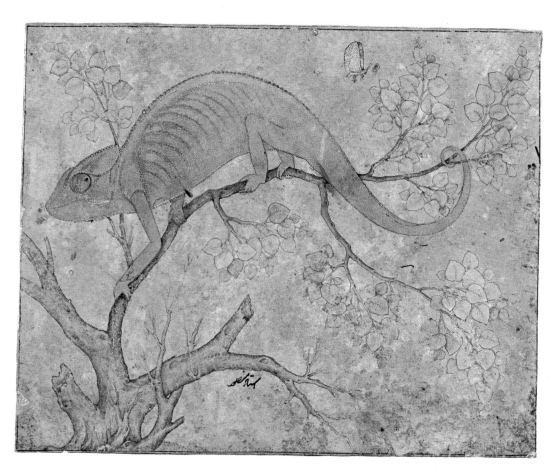

15 *A Chameleon on a Branch*. Signed: Ustad Mansur. Mughal; ca. 1615. H. 11.1 cm., w. 13.8 cm.
Lent by gracious permission of Her Majesty Queen Elizabeth II

Indian Drawings and Painted Sketches

16TH THROUGH 19TH CENTURIES

By Stuart Cary Welch

The Asia Society

In Association with John Weatherhill, Inc.

INDIAN DRAWINGS AND PAINTED SKETCHES *is the catalogue of an exhibition shown in the Asia House Gallery in the winter of 1976 as an activity of The Asia Society, to further greater understanding between the United States and the peoples of Asia.*

AN ASIA HOUSE GALLERY PUBLICATION

© *The Asia Society, 1976*
Library of Congress Catalogue Card Number 75-29780
ISBN: 0-87848-046-3

This project is supported by a grant from the National Endowment for the Arts, Washington, D.C., a Federal Agency.
The Friends of Asia House Gallery have also made a generous contribution to the exhibition.

Contents

Foreword

The Asia House Gallery is pleased to sponsor, with the Fogg Art Museum, this exhibition of "Indian Drawings and Painted Sketches." To our knowledge, it is the first of its kind and as such, it continues the tradition of other Gallery efforts in providing new information about a significant and yet relatively unknown aspect of Asian art.

From another point of view, however, this is far from being a "first." Rather, it should be thought of as "the latest," as it is the most recent in a number of successful collaborations between the Gallery and Cary Welch, Senior Lecturer in Fine Arts at Harvard University. Mr. Welch began this happy relationship in 1963 with the exhibition and catalogue of "The Art of Mughal India." This was followed two years later by his study of northern Indian painting entitled "Gods, Thrones, and Peacocks." Then, in 1973, he mounted a survey of Indian paintings from American collections, which he called "A Flower from Every Meadow." This, then, is part of a continuing series of scholarly and beautifully chosen exhibitions from Mr. Welch, and we are pleased to note that another is already in the planning stages.

That the subject of drawings has been so ignored by scholars and museums is indeed astonishing as Mr. Welch remarks in his introduction. He explains this apparent neglect by pointing out that sufficient examples of high quality were simply not known until very recently. It should also be noted that a few fine drawings have been included in exhibitions and publications devoted to Indian painting, including those of The Asia Society. This suggests that little effort has been made to separate the two or to define the qualities and the characteristics of Indian drawings. In his introduction, Mr. Welch gives a broad definition but wisely avoids exactitude and explains his reasons for extending the scope of this study to include painted sketches. In this way, he has shunned long semantic discourse and definitive labels and allows the objects themselves to define the limits of this exhibition.

The study of Indian drawings should not be considered esoteric or particularly difficult. The sort of works represented here are exactly similar to those we would expect to find in surveys of Western drawings. Realistic, grotesque, or satirical portraits, whether incomplete notations or finished sketches, studies for

decorative ornament, fantasies, drawings from nature, even drawings that have been pricked for transfer and cartoons for wall paintings; all are included in this exhibition and will be familiar types to any who are acquainted with drawings from the artistic traditions of the West. Certainly many of these parallel developments can be attributed to the extensive exposure to Western art of the Renaissance which occurred in India as early as the sixteenth century. Also, as the demands of the craft of drawing are the same wherever it is practiced, we can expect similar approaches and solutions to develop, independent of outside influence.

One last observation might be of further help in our understanding of these works. It can be rewarding to study them by looking beyond their obvious quality and into what they have to tell us of past lives and aspects of Indian social history. Much can be learned about the artists who made these drawings, of the patrons for whom they were made and the shifting tastes and currents of their times. Here, we refer not only to tastes and changes in art itself, but to such subtleties as choice of subject matter and evidence of various influences and new interests. Mr. Welch gives some invaluable guidelines to these undercurrents in his introduction and, with his observations, we come to see these sketches both as historical documents and as newly discovered masterworks.

Many institutions and individuals have helped in this wide-ranging effort. Those with whom Mr. Welch has been involved in his long and dedicated study are acknowledged by him and we add our thanks to his. We are, of course, deeply indebted to the many lenders who have shared their works with us for a long enough period to allow for the tour of the exhibition.

Daniel Robbins, former Director of the Fogg Art Museum, enthusiastically endorsed his museum's co-sponsorship of the exhibition and his early interest was the catalyst to our advance planning. In February 1973, Mr. Welch was the recipient of a JDR 3rd Fund travel grant which enabled him to visit India to study the major collections and select works for the exhibition. During the incumbency of Porter McCray, Director of the Asian Cultural Program of the Fund from 1963 to 1975, Asia House Gallery has received many similar grants from this source and we wish to thank him for his support and sustained interest in our exhibition program. Once again, a generous grant from the National Endowment for the Arts has helped to defray some of the organizing costs, and the Friends of Asia House Gallery have provided matching funds.

To clear the way for permission to borrow the various drawings from India itself, we have depended upon many new and old friends. In Washington, His Excellency Triloki Nath Kaul, Ambassador of India, has shown interest and given great encouragement from the very beginning. We are also grateful for the assistance and advice given us by Inam Rahman, Minister of Education and Science of the Indian Embassy. In New Delhi, we have received great cooperation from Dr. S. Nurul Hasan, Minister of Education and Social Welfare, and Dr. Kapila Vatsyayan, Joint Educational Advisor of the Ministry of Education and Culture, who has guided us along official paths. Mrs. Soonu Kochar of the Indian Council for Cultural Relations in New Delhi has also lent a friendly hand. Dr. James Roach and David T. Schneider of the United States Embassy have been most helpful and Dr. Grace Morley, Head of the ICOM Regional Agency in Asia, has given considerably of her time and advice throughout our negotiations.

In addition to all of the assistance we have received from the private collectors, we wish to thank the following colleagues for seeing to the various details we have imposed on them: Jan Fontein of the Museum of Fine Arts, Boston; Arnold Wilson and Peter Hardie of the Bristol City Art Gallery; A. K. Bhattacharyya of the Indian Museum in Calcutta; Jeannine Auboyer and Andrée Busson of the Musée Guimet, Paris; Joan Lancaster and Mildred Archer of the India Office Library in London; John Irwin and Robert Skelton of the Victoria & Albert Museum; C. Sivaramamurti, former Director of the National Museum in New Delhi, and P. Banerjee, the Acting Director; Richard Ettinghausen and Marie Swietochowski of The Metropolitan Museum of Art in New York; and Robert Mackworth-Young and Jane Low of the Royal Library in Windsor Castle.

<div align="right">

ALLEN WARDWELL

Director, Asia House Gallery

</div>

Acknowledgments

Good, healthy ideas are contagious. This exhibition would not have happened without Paul J. Sachs's infectious zeal for drawings, an un-disease nurtured to epidemic proportions at the Fogg Art Museum during his lively years of directorship and teaching. One of his first and most admired students was Gordon Bailey Washburn, to whom I should like to dedicate this exhibition and catalogue, who became director of the Albright Art Gallery of Buffalo shortly after completing his studies at the Fogg. While there, Gordon further spread the excitement about drawings by holding a remarkable exhibition in 1935 entitled "Master Drawings," selected from the museum and private collections of America. This was the first art exhibition I recall seeing, an unforgettable experience enjoyably reinforced by an excellent catalogue which is now one of the most devotedly patinated volumes in my library. During the course of gathering and describing the present exhibition, I have often turned to this model of what a catalogue should be. More often, I have turned to Gordon himself, whose initial support and continuing help in this project have been immeasurably generous and improving.

Having been inspired by the Fogg Art Museum's long-standing delight in drawings, it is warmingly appropriate that this exhibition is a joint venture between the Fogg and The Asia Society, the two institutions I most cherish. Had I not profited from nearly three decades of contact with drawings at the Fogg, along with such enlightening experiences as courses with Jakob Rosenberg, many brief but stimulating conversations with Agnes Mongan (who can be considered the personification of the Sachs legacy), and frequent exchanges with Philip Hofer, Max Loehr, and John Rosenfield, as well as many other Fogg connoisseurs, this exhibition would be far less impressive. I hope that they will share my excitement over the material.

Although The Asia Society has brought many pleasures over the years, one of the foremost for me has been working with Virginia Field. Her creatively imaginative designing, diplomatic but efficient editing, and invariable calm continue to amaze and delight. I am also grateful to Allen Wardwell, who became involved in this project well after it began but has contributed sage counsel and dealt splendidly with the

laborious and time consuming problems that beset international exhibitions. I should also like to thank Sarah Bradley for her sharp-eyed but invariably sympathetic work on the catalogue.

At the Fogg, I am most grateful for the enthusiastic support of Daniel J. Robbins during whose directorship this exhibition was planned and for the continuing help of Seymour Slive (another Fogg drawing-wala!) and his assistant, Suzannah Doeringer. Without Jane Watts's frequent kindness and help, all of my projects would founder; whereas if Mrs. Horace Frost ever withdrew hers, all progress would cease. I am also thankful to Terence McInerney for connoisseurly advice and for preparing the bibliography. Marjorie Cohn and Louise Bluhm, *conservateuses extraordinaires*, greatly deserve our gratitude, as do James Ufford and Michael Nedzweski, who took many of the photographs in this publication. As always, Laurence Doherty and his staff have helped with devoted interest and hard work.

Praise is due Robert Steinberg for having developed a special technique whereby large photographs can be contact-printed on cloth. These promise to greatly enhance the exhibition by adding a variation of scale.

When assembling such an exhibition, one begins with a set of ideal choices, the pictures one most wants but might not be allowed to borrow. Thrillingly, our generous lenders agreed to send all of the drawings I most wanted. To say that I am grateful to them is to understate.

Many friends, in addition to the museum personnel mentioned by Allen Wardwell, have contributed time and effort and invaluable advice. In England: Mr. and Mrs. W. G. Archer, Mr. and Mrs. Howard Hodgkin, Sven Gahlin, Ellen Smart, and Clifford Maggs. In this country: Professors Annemarie Schimmel, Martin Bernard Dickson, Wheeler Thackston, and Milo Cleveland Beach. In India: the late Dr. Moti Chandra, Pramod Chandra, Asok Kumar Das, B. N. Goswamy, Hargopal Jhamb, Karl Khandalavala, Rai Krishnadasa, Anand Krishna, M. S. Randhawa, Pranabranjan Ray, Sushil Sarkar, and Chandramani Singh.

STUART CARY WELCH

Lenders to the Exhibition

Prince Sadruddin Aga Khan

Mr. Ralph Benkaim

Mr. Edwin Binney, 3rd

Bristol City Art Gallery

Her Majesty Queen Elizabeth II

India Office Library and Records, London

Indian Museum, Calcutta

Jagdish and Kamla Mittal Museum of Indian Art, Hyderabad

The Metropolitan Museum of Art, New York

Musée Guimet, Paris

Museum of Fine Arts, Boston

National Museum, New Delhi

Victoria & Albert Museum, London

Introduction

Astonishingly, Indian drawings have never before been the subject of a full-scale exhibition. At the end of the introduction to his pioneer study of this subject, Ananda K. Coomaraswamy wrote that the reproductions in his book would be "welcomed as a revelation of an exquisite but hitherto almost unknown art" (*Indian Drawings,* vol. 1 [London, 1910], p. 31). Today, sixty-five years later, this subject is scarcely better known than it was then, in spite of the tremendous and increasing excitement about Western drawings on the part of specialists and public alike.

Why such neglect of one of the most rewarding areas of Indian art? Primarily, this has been due to the unavailability of material. Few of the early collections of Indian painting included more than a few drawings of high quality. In his monographs, Coomaraswamy was unable to illustrate enough brilliant examples to warrant his enthusiasm. Eighteenth-century English collectors such as Mr. Richard Johnson, whose Indian pictures are now one of the treasures of the India Office Library in London, owned many drawings; but the level of quality ranges from that of a small number of masterpieces such as "Emperor Jahangir Embracing Prince Khurram" (No. 18) to a profusion of desiccated academic exercises. The same situation prevailed in the British Museum and in Indian public collections. One gets the impression that until very recently dealers and collectors of Indian pictures considered drawings little more than "study material" to be given as presents when completed miniatures were sold or bought. When such discerning connoisseurs as Victor Goloubew (whose marvels included "Inayat Khan, Dying," No. 16), William Rothenstein, Laurence Binyon, or Coomaraswamy himself bought exceptional drawings, they were thrilled undoubtedly, but probably felt that such acquisitions were less consequential than comparably attractive paintings. Although specialized collections of Western drawings are now legion, we know of no one who limits himself to Indian drawings.

In the future, we shall look back to the nineteen-fifties and sixties as the golden years for collecting Indian drawings. During this period, the contents of English country houses were emerging at the London

auction houses and, more important, large numbers of Indian pictures came on the market because Indian princely families whose power was waning could no longer afford such possessions. Indian and Western museums and private collectors began by browsing and eventually scurried to purchase the stacks of pictures offered by dealers. Simultaneously, scholars and curators such as the W. G. Archers, Douglas Barrett, Herman Goetz, Moti Chandra, Rai Krishnadasa, Karl Khandalavala, and several others sponsored exhibitions and wrote books about this treasure trove from palace godowns. But even as recently as the late nineteen-sixties drawings, as compared to paintings, were greatly neglected, and only a few years earlier an Indian enthusiast acquired thousands of drawings, some of magnificent quality, for little more than their worth as scrap paper. Significantly, this spectacular buy was made from a family of artists, not from a royal collection. The princes, it seems, were not ordinarily interested in such material, which remained in the workshops of the artists, who passed it on to their descendants in the same way that other Indian craftsmen transmitted tools and trade secrets to their sons and grandsons. On those occasions when we have had the good fortune to inspect princely collections, we have invariably been disappointed by the absence of drawings other than a few highly finished ones. (We have heard, however, that the Jaipur City Palace collection includes large numbers of preparatory drawings. Apparently the ateliers were in the palace and such materials remained there. Nevertheless, a large number of Jaipur drawings, including Nos. 60 and 61 here, were collected by Dr. Coomaraswamy. Most of them are now in the Ross-Coomaraswamy Collection in the Museum of Fine Arts, Boston.)

Without further ado, we must attempt the impossible and try to define the word "drawing." We are inclined to use it loosely, in reference to essentially two-dimensional works of art in any medium in which color is absent or subordinate. To cite extreme cases, drawings *could* be arrangements of rocks on a field or smoke trails in the sky. Conveniently, Indian drawings put no such strains upon us. The pictures in this exhibition were mostly done with brush or pen and water-soluble pigment on paper. The sole exception is a pair of folios from a traditional palm leaf manuscript in which lines were scratched into the leaves with a sharp metal point, after which black pigment was rubbed into the incisions (No. 4). While the technique of the other pictures is basically simple, the varieties of paper, brushes, and reed pens used to make them are considerable. As one might expect, the papers employed by folk artists (as in Nos. 1, 2, and 5) were rough and fibrous as compared to those available to the more sophisticated. The portrait of a kneeling courtier (No. 6), for instance, was drawn by a great Mughal court painter, Mir Sayyid 'Ali, on exceptionally fine paper. Presumably he had brought it with him from Iran, where he had previously been employed by Shah Tahmasp, one of the world's most renowned patrons. While a village artist would have drawn with a crude reed or rustic brush dipped into a mixture of soot and water with a bit of glue added to bind them together, so refined a craftsman as the Mir would have worked with a painstakingly prepared brush composed of hairs plucked from baby squirrels' or kittens' tails, artfully balanced and shaped and set into a quill. The tips of brushes had to be black, as white ends did not clot properly. (For this and other invaluable technical information, see: Moti Chandra, *The Technique of Mughal Painting* [Lucknow, 1946], pp. 35–36.) His ink—known to us as bister—would have been prepared with equal care by burning special

sorts of wood and mixing the carbon with water and probably with a small quantity of gum arabic. It would then flow smoothly and dry to a rich, velvety blackness or, if thinned, to an even, gritless wash. Happily, the rough and ready tools and materials of folk artists were as ideally suited to their purposes as the infinitely delicate ones of the imperial court artists, requiring years of apprenticeship to learn to make, were to theirs.

Although most of the materials and techniques employed in the works assembled here need little explanation, a few further comments about them might prove helpful. Sharp-eyed visitors may notice that a number of the drawings reveal pin pricks along their outlines (Nos. 46 and 62, for instance). These were caused by tracing, or pouncing, a method by which motifs or entire designs could be transferred from an old picture to a new one by placing a piece of transparent gazelle skin over or under the original and pricking along the desired outline through both surfaces. The pounce was then placed on top of fresh paper and ground charcoal was rubbed through the holes, leaving a blurred, black line that would next be reinforced by drawing over it with a brush. Also noticeable are the seemingly haphazard though appealing areas of opaque white, caused by covering over mistakes in order to redraw the lines (No. 53). These corrections would, of course, have been concealed had the composition been carried to its final state of being a painting. White was also employed as a ground, particularly at the court of Kangra in the Punjab Hills (No. 77). It was evenly laid over a support made of several layers of fine paper glued together to form cardboard. Then the white surface was burnished by laying it face down on a smooth surface and rubbing the back with a special tool of polished agate or crystal. The resultant ground provided a perfect surface for fine brushwork, which could moreover be invisibly corrected by covering mistakes with more white and further burnishing.

When assembling this exhibition, a joyous labor for at least a decade, we realized that it would be more appealing if we included painted sketches as well as monochromatic drawings. In part this decision was prompted by the fact that artists do not work within the limitations set by purists. Thus many inspired pictures fall somewhere between the categories of drawing and painting, as in "A Raja Entertained by Musicians and Dancers" (No. 74), a technically conventional brush drawing to which the artist has added delightful strokes of color. Inasmuch as the artists themselves could not resist such practices, we saw no reason to resist including their pictures here!

Although it would be impertinent to claim to know the inner motivations of artists, the outer purposes for which the pictures in this exhibition were made varied greatly. A series of small folk pictures from the Punjab Hills is from a set of cards comparable to our Tarot (No. 2). Threads were attached to each, to be pulled by the villager whose fortune was being read by the local seer. A bold line drawing of a courtesan holding a parrot was made as a souvenir to sell as cheaply as possible to a visitor at the Kalighat temple near Calcutta (No. 5). A page from a South Indian manuscript was intended to enlighten the reader about the holy acts of Rama (No. 3). Many of the pictures here are portraits, comparable to those in family photograph albums. A caricature of "Drunken Musicians" (No. 73), on the other hand, must have recalled a riotously funny anecdote of life in the Punjab Hills. Inasmuch as historical records were serious concerns

of the Mughals, "The Battle of Samugarh" (No. 21) was accurately drawn and painted, perhaps preparatory to a more finished version for one of the official historical manuscripts. Two pictures from the Deccan, one a horse made up of calligraphy and ridden by a mystic (No. 31), the other a *mihrab*, or prayer niche, composed of archaic script (No. 38), were made as talismans to avert troubles. A superb image of a chameleon (No. 15) was one of many natural history subjects made for the Mughal emperor Jahangir (r. 1605–27), while a much larger bird study (No. 26) was almost as sensitively rendered on English watercolor paper for Lord Valentia, a Britisher on his grand tour in about 1800. In form the study is identical to those in the voluminous sets illustrating India's flora and fauna which were officially commissioned from Mughal-trained artists for an economic survey.

Other pictures, comprising almost half of the exhibition, were done not as finished works for sale or for individual patrons but by the artists for their own purposes, either self-improvement or, more often, for pure delight. A sketch such as "Three Moods" (No. 54) invites us into the private life of the artist and reveals his sense of fun and Rabelaisian spirits with a bitingly satirical brush. Inasmuch as such intimate works of art, done with no concern for critics, at their best reveal more than completed pictures, we have selected many from the enormous quantities available. Interestingly, all are by artists from the Rajput courts of Rajasthan and the Punjab Hills. Perhaps Mughal and Deccani masters left fewer traces of such unguarded moments.

To avoid the monotony of rows of sketches not much larger than postage stamps, we strove to find large pictures for this exhibition. In doing so, we ran the risk of giving a false impression; for most Indian drawings and miniatures are small, many of them intended as book illustrations. Others, particularly at the Muslim courts of the Mughals and in the Deccan, were bound into albums after being given richly ornamented borders (Nos. 10, 13). At the courts of the Rajputs, who were Hindus, most pictures other than those in books were kept in stacks, to be brought out and enjoyed one by one. For protection against insects and damp, the stacks were neatly wrapped in squares of cloth, the four corners knotted at the tops of the bundles. Although religious pictures were often mounted in shrine rooms, it was not the custom to frame and glaze drawings or miniatures for hanging on walls. Those one sees so exhibited in India today follow English custom. In early seventeenth-century Mughal pictures, however, one occasionally sees small paintings, apparently miniatures on paper, attached to walls. Usually, these depict European subjects, and one can assume that Europeans suggested the practice to the emperors. Wall paintings, however, were common in forts and palaces as well as temples. At least three of the drawings here were cartoons for such compositions (Nos. 60, 61, 70).

Although Emperor Akbar (r. 1556–1605) studied painting as part of his princely education, as other Mughal and Rajput noblemen must have done, most if not all of the pictures here were made by professionals. Their positions in the world ranged from that of humble village craftsmen to the emigré Iranian Abd as Samad (see No. 10), who was a distinguished courtier and government official under the Mughal emperors Humayun (r. 1530–56) and Akbar. Basawan (see Nos. 7–9), often considered the greatest of all Mughal artists, was a Hindu of modest background whose talent and intelligence earned him a distinguished

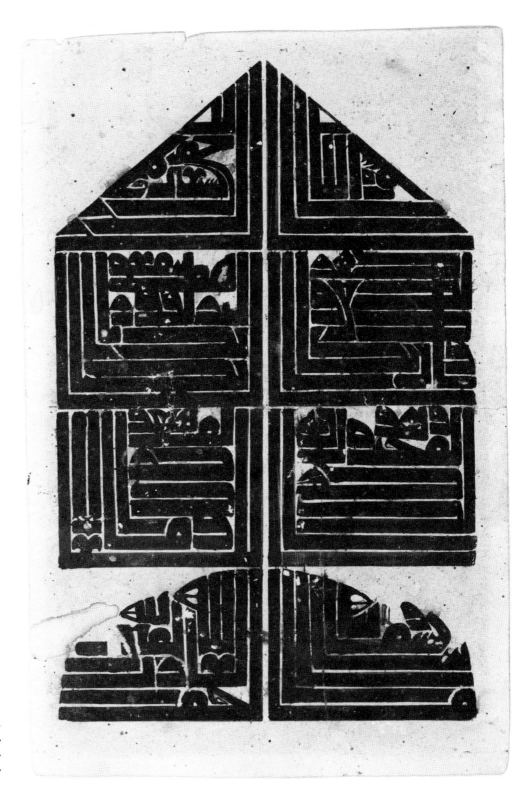

38 *A Mihrab in Kufic Script.*
Deccan, Hyderabad (?); ca. 1800.
H. 20.6 cm., W. 13.6 cm.
Lent anonymously.

position in the imperial workshop. Nevertheless, his role at court would have been that of a useful facto-tum, on much the same level as a servant. One can imagine that while he occasionally shared badinage with the mighty Akbar, ordinarily he would have stood at attention in the imperial presence, with his hands folded in front of him. Just as the Mughals employed Hindus to serve them, so did the Rajputs hire Muslim artists, even to paint Hindu religious subjects. As in Europe, court painters were expected to supply designs for the decorative arts, such as carpets, embroidery, and metalwork, and to superintend the ornaments for marriages, festivals, and other holidays. A Kotah drawing of dancing girls forming a swing (No. 48) may well have been made as a guide to the performers.

At the Mughal, Deccani, and Rajput courts, artists were probably paid according to fixed scales, based upon whether they were apprentices or masters and upon their patrons' evaluation of their accom-plishments. Spontaneous bonuses for especially admired pictures must have encouraged the artists to do their best. These rewards might have been sumptuous coats of honor, elephants, or even villages from which the artists would have received revenues for life. At many courts, artists were expected to make offerings (*prasad*) of pictures on special occasions. As these were usually signed and dated, they are ex-tremely useful to art historians.

While working, painters sat cross-legged on the ground, with a drawing board propped up on one knee and little shells of paint and water conveniently at hand. Before starting to draw, traditional Hindu religious painters meditated, in order to calm and focus their minds and to envision the gods they would represent. Breathing exercises and yoga may well have been part of such preparations. It seems likely that Hindu artists working for the Rajputs and Mughals continued such practices, even though they often painted secular subjects. Possibly, too, their Muslim colleagues availed themselves of comparable practices.

We have given a sense of who the artists were and how they worked, but thus far have overly ne-glected the patrons, their partners in creation, whose role may have been greater than in the West. What a cast we should have if we could conjure up these individuals and arrange them on a stage! However fas-cinating the artists must have been as people, outwardly they would have been drab by comparison. Our pantomime of their employers would begin modestly, with villagers in white dhotis and a priest or two in saffron robes, before brightening with the worldlier Rajputs, Mughals, and Deccani princes. Their apparel would scarcely have been outshone by a peacock's. Moreover, many of them were of extraordinary intelligence, power, and charisma.

The most potent figure of all would probably have been Akbar, the third Mughal emperor, who put his stamp not only upon his successors but upon most of India. The combination of scientific observation, philosophical contemplation, and insightful study of mankind apparent even in the small number of pic-tures made for him that we are showing here hints at the range of his concerns (Nos. 7–12). Akbar's curi-osity about man and the world was inherited by his son, Jahangir (r. 1605–27), whose artists' increasingly subtle skills enabled them to portray it all with even more precision, though with less grasp of interrela-tionships. While his father saw a macrocosm, Jahangir (whose name means "World-Seizer") commissioned his painters to create jewel-like fragments of the microcosm. Unquestionably the most connoisseurly of

all our patrons, he reduced the size of the royal ateliers, keeping only the great masters and their best apprentices and assistants, who worked with awesome precision and fineness.

A drawing for a historical manuscript showing Jahangir with his son Prince Khurram, who was to reign as Shah Jahan (r. 1627–58), vividly describes the splendor of Mughal India at its peak (No. 18). Already, however, increasing formality and orthodoxy presaged future troubles for the empire, which nonetheless lingered on for over two hundred years, like a beautifully balanced and perfectly wound gyroscopic top. Under the austere Emperor Aurangzeb (r. 1658–1707), the Mughals expanded into the Deccan, overreaching the area they could control practically. More and more, the top wobbled, continuing largely because it had been so well designed and set in motion by Akbar. Portraiture, the essential Mughal subject, provides clues to the rise and fall. Basawan's likeness of a vigorously appealing scholar, earthy and bulbous, absorbed in his study (No. 7), embodies the increasing power of Mughal India under the young Akbar. Less wholesome, though unequalled for sensitivity, is the portrayal of Jahangir's opium-addicted courtier, Inayat Khan (No. 16), who was near death when brought to court and portrayed at the emperor's command. Under Akbar, the unfortunate Inayat would have been disciplined before reaching such a state; but had his habit escaped detection until he became a bundle of skin and bones, Akbar would never have wanted a portrait to remind him of such gruesomeness—not that he was squeamish, for Akbar commissioned artists to paint gory executions, guts and all. But such subjects were useful warnings and underscored the power of the empire.

A tenderly observed conversation-piece showing Shah Jahan's grandson Sulaiman Shikoh with his tutor (No. 20) epitomizes the tranquil atmosphere in the rarified precincts of the Peacock Throne. Protected and indulged by armies of servants, insulated by moats, walls, a sequence of gardens, and all the formality and etiquette that generations of emperors and courtiers could devise, it is no wonder that the imperial family was beginning to lose its grasp of reality. By the time Emperor Muhammad Shah (r. 1719–48) was sketched (No. 23), it would have been laughable to inscribe a palace wall, as Shah Jahan had, with verses reading, "If there is Heaven on Earth, it is here, it is here, it is here." The seventeen-thirties were hardly the time for Mughals to rejoice, or even to face up to reality. The empire was shrinking, and Muhammad Shah sought refuge in his garden. His artists scarcely dared look closely at the imperial countenance, which they recorded as an impassive mask. They could, however, enjoy his garden with the emperor, exploring every tree, kiosk, and blossom. A final Mughal likeness brings to life a nineteenth-century Delhi poet, Hakim Momin Khan (No. 24). This is probably the only Mughal portrait shown here that was not made for a member of the imperial family. By now, the Grand Mogul himself, who was a capable poet, was resigned to his political weakness. Whatever power remained in his dismembered empire stemmed not from riches or arms but from poetry, manners, customs, and art.

Much of the empire's might had now been taken over by the British, who admired Mughal pictures for their technical skill and naturalism. As long ago as the seventeenth century, Sir Thomas Roe, King James the First's emissary to the court of Jahangir, had shown the emperor an English portrait miniature. Jahangir took this as a challenge and ordered his leading artist to copy it, a task accomplished so perfectly

that Sir Thomas was barely able to distinguish the original (Thomas Roe, *The Embassy of Sir Thomas Roe to India 1615–1619*, ed. W. Foster [London, 1899], vol. 1, pp. 213–214). With the breakdown of the empire and the gradual filling in of the power vacuum by the British, Englishmen were able to hire artists trained in the Mughal workshops. Thus on our stage of patrons we see a number of seemingly out of place foreigners, such as twenty-seven residents of Calcutta in the eighteenth century, whose ghostly and now anonymous visages crowd a sheet of cardboard (No. 25). While English men, and women such as Lady Impey, were patrons on a large enough scale to warrant discussion, the British were more important for patronage as a community than as individuals. Lord Valentia, for example, who acquired the portrait of a Gingi vulture (No. 26) during a brief visit to Calcutta in about 1800, can hardly be considered a significant force in Indian art. None of the major figures in British Indian history, such as Lord Clive, Warren Hastings, or any of the viceroys, seem to have put down their swords or state papers long enough to take art patronage seriously.

Like the Mughals, who were later arrivals in India, the sultans of the Deccan were Muslims. Unlike the Mughals, whose art was a synthesis of foreign and indigenous styles, the Deccani rulers retained strong artistic links with the Ottomans, Uzbeks, and Safavids. They would have found Mughal poetic realism vulgar and raw, preferring less earthbound styles in which the rhythmic interplay of traditional Muslim arabesque lent ornamental graces to everything from portraits to elephant combats. Likenesses of the princes and courtiers of Bijapur, Ahmednagar, and Golconda never delve into personality through the sort of exacting exploration of the surface, warts and all, known to us from Mughal examples. Nevertheless, their gentler, more fanciful method often reached the soul as successfully (Nos. 29, 30, 32, 35). Regrettably, history has not been as generous to the Deccani rulers as to the Mughals, in part because they lacked the northerners' devotion to record keeping and biography. As a result we know far less about their lives. Deccani pictures earlier than the eighteenth century are also far rarer than Mughal ones; scarcely enough having survived to give a full sampling of their styles.

World history has known few ruling classes as colorfully chivalrous as the Rajputs of Rajasthan and the Punjab Hills, whose caste responsibilities were to rule, hunt, love, fight, and worship. A look at the drawings and sketches made for them and assembled here tells much of their lives, tastes, and foibles. Amar Singh II (r. 1698–1710), the Rana of Mewar, descended from the sun and the foremost noble of Rajasthan, is shown here at worship (No. 39). As in most Rajput portraits, the artist chose to concentrate on the Rana's salient characteristics rather than to give a fully rounded interpretation as a Mughal would have. The anonymous artist tells us that his prince was a mild, devout man of sterling character, all of which is born out by history. Larger than most Mughal portraits, by which the Rajput ones were inspired, it is also simpler, with less modeling and a wiry outline that tends to flatten forms.

Prior to the coming of the Mughals, Rajput portraiture must have been rudimentary, showing princes and their families only as donors in religious paintings. During the centuries of Mughal influence documented in this exhibition, the Rajputs continued to commission large numbers of religious pictures, as well as to follow the new vogue for secular ones. "Krishna Spies on the Gopis" (No. 43) was drawn at

the court of Bundi, where generations of patrons and artists never tired of the exploits of the god Krishna and his love for the cowgirls, or *gopis*. Proud soldiers who led armies against their Rajput rivals and on behalf of the Mughals, the Bundi rulers always remained loyal to their local artistic idiom. Typically, their artists showed the court or gods and goddesses (and at times the prince and his wives disguised as gods and goddesses) disporting in romantic groves of voluptuous plantains further enriched by lily ponds, amiable deer, soaring birds, and explosions of blossoms.

The nearby and related court of Kotah was particularly a center of drawing, where artists gratified the rulers' apparently insatiable tastes for pictures of animal combats, battles, and hunting scenes. Inasmuch as the Kotah rulers often served the Mughals in their campaigns against Golconda and Bijapur, it is not surprising that the stylistic trend of the school was established when the Kotah patrons hired a great Deccani master artist of unknown name, who was possibly accompanied by his atelier as well as family. The stylistic roots of this brilliant artist can be traced back to fifteenth-century Iran, specifically to Turkman Tabriz, where painters specialized in lively representations of demons, phoenixes, and dragons battling with tooth and claw. His Kotah elephant combat (No. 44) retains much of the same form and spirit, with its calligraphic flourishes and stunning power. In wizardry of line and dynamic designing, the Kotah artists, urged on by their zestful princes, reigned supreme in Indian art well into the nineteenth century (see Nos. 44–57).

Although most Rajput rulers maintained artists as functionaries of the state, along with an army, cavalry, elephants, all manner of servants, distillers, dancing girls, and men of God to mention but a few, some were more devoted to painting than others. While one could expect to find important schools of painting at the major courts such as Mewar, Marwar, Bundi, Jaipur, and Bikaner, some of the smaller ones surprise us by the quality and individuality of their styles. One such was Devgarh, where the princes held the lesser title of "Ravat" and employed a small number of excellent painters during the late eighteenth and early nineteenth centuries (see Nos. 58, 59). Although hardly a minor court, Kishangarh's school of painting is at least as important as that of the infinitely more powerful house of Marwar (see No. 64) of which it is a cadet branch. To a considerable degree this was due to the poet-ruler Sawant Singh (r. 1719–57), whose artists worked in a style of Mughal refinement and technique with added elements of strangeness, savage wit, and fervid religiosity, a paradoxical combination comparable in experience to watching a very properly dressed gentleman suddenly break into an ecstatic religious dance (see Nos. 65–69).

Few carryings-on as odd as those in Kishangarh pictures were recorded in the courts of Jaipur or Bikaner, each of which supported scores of artists at least from the seventeenth century through the nineteenth. Among the most moving Jaipur pictures are two cartoons for a wall painting in the City Palace, one showing Krishna (No. 60), the other a pair of musicians (No. 61). For restrained elegance and majesty, these can hardly be equalled in Rajput art. Raja Karan Singh of Bikaner (r. 1631–1669/74) was portrayed in profile holding a Deccani sword, no doubt one he had captured as a Mughal officer (No. 62). His family had been closely allied to the Mughals since the time of Akbar, and their artists invariably worked with Mughal precision. Their originality, however, stems from a certain somberness of palette and mood and

a penchant for lonely figures set in the endless space of the desert round Bikaner. While in the Deccan, Raja Karan and his sons hired local artists, one of whom probably drew the battle scene from a *Ramayana* included here (No. 63). Religious subjects, as we have seen, were frequently portrayed at the Rajput courts, in part perhaps to remind the Mughals of Rajput independence of spirit. Akbar had tried to replace Hinduism by creating a synthetic new religion with which to unify the Muslims and Hindus and thereby strengthen the empire. Only his most intimate friends and their sycophants espoused it and none of the leading Rajput princes ever denied their faith.

The Rajputs of the Punjab Hills states shared most of the pursuits and interests of those from the plains of Rajasthan and Central India. One of these was painting, which flowered there in numerous schools, as can be learned from W. G. Archer's *Indian Paintings from the Punjab Hills* (London, 1973). A natural division exists between the Rajput art of the Hills and elsewhere, based upon differences of style and spirit. To some degree, these differences resulted from geography and climate. Another factor is that Mughal influence penetrated the Hills more gradually and less intensively, because far fewer Hill Rajputs entered the imperial service. Moreover, the Buddhist world to the north kept alive ancient artistic traditions, as expressed in richly colored *tankas* (religious pictures on cloth) and manuscript illustrations stylistically descended from the eleventh-century art of the Palas of Bengal. The proximity of such schools of art, with their schematic and conventionalized rather than naturalistic modes, countered Mughal influences until the early eighteenth century. Prior to the time when Mughal ways became pronounced, color was so integral a part of pictorial art that drawings hardly mattered and we have seen no outstanding examples.

The earliest Hill picture here is a finely delineated brush drawing of a mother playing with two small children, made by an artist of the court of Chamba (No. 71). He has caught the gesture of an infant swinging over a maternal shoulder, and yet his observation stopped short of true portraiture. The figures are generalized, as so often in Hill painting, though it must be pointed out that a few of the most striking Rajput portraits were done there. Closer study of life is apparent in another drawing from Chamba showing a family of elephants welcoming home their bull, whose broken chains reveal that he had escaped from captivity (No. 72). Although we cannot even guess for whom the amusing caricature of drunken musicians was made (No. 73), we can be sure that the patron spurred on his artist, who played angular games with his subjects' noses, jaws, and bony limbs, twisting and pulling them like taffy. Many an evening must have been spent chewing betel nut and guffawing over this reminder of an outrageous concert.

One of the best known Hill patrons was Raja Balwant Singh of Jammu, who reminds us of Emperor Jahangir both in his fanatic dedication to painting and in his appreciation of meaningful trivia. Through the eyes of his favorite artist, Nainsukh, we have seen him not only carrying out the usual royal activities of hunting and watching dancing girls, but also stripped to the waist writing letters on a hot night in camp or, as a tiny, lonely figure, smoking on the roof of his palace (Archer, op. cit., vol. 2, "Jammu," nos. 42, 52). His life it seems was not always happy. An enigmatic and peculiar drawing in the Bharat Kala Bhavan, Banaras, has been interpreted most convincingly by W. G. Archer as an allegory of personal disaster and salvation (Archer, op. cit., "Jammu," no. 53). As always, Nainsukh drew the Raja, there shown twice in a

weird boat on a nightmarish river, with the utmost sympathy and dignity. There must have been close sympathy between them. Nainsukh probably also drew the mysteriously dramatic picture shown here of a Raja slashing a large fish (No. 76).

Another active and notable Hill patron was Raja Sansar Chand of Kangra (r. 1776–1824), whose devotion to painting survived his political ups and downs. The illustrations to the love story of Nala and Damayanti (No. 77) were made for him at the end of the eighteenth century by an artist or group of artists whose lyrically cursive brushwork has earned the series a high position in Indian art. The less delicate portrayal of a seductive courtesan (No. 78), reminding us of the Rajput proclivity for earthly as well as spiritual pleasures, may also have been his.

Just as Indian noises seem louder than others, Indian smells more overwhelming, and Indian food hotter or sweeter or more pungent than any other, so does Indian art have a uniquely potent character. Even her drawings, literally colorless as they may be in most instances, are imbued with some stirring essence which vitalizes all Indian art. We find it in the most conspicuous of all works of art of this period, one which may help to explain what is Indian about Indian art, the Taj Mahal.

This great building has been hailed as a supreme example of classicism—to us it is so supreme in fact, so vast and rich and wildly chaste in its white and black marble that it is not classical at all. Rather it is another instance of Indian hyperintensity, comparable to the noises, smells, tastes, and sounds. It would be hard to find anything classical in Indian art, if by classical we mean balanced, harmonious or restrained.

The Taj Mahal has also been praised by assorted Europeans as a magnificent design by an Italian architect, and admirers of Iranian architecture have seen it as the culmination of Safavid structures. Rubbish! Part of India's power has been to welcome people and ideas and then make them her own, with a technical perfection bordering on virtuosity, a quality found in Indian art from the earliest times onward and apparent in the pictures here from the folk level to those of the most elevated courts.

Another folly repeated about the Taj Mahal claims it as a horrible monument to one man's domination over the masses, a triumph of inhumanity. For all its geometry and arabesques and Qur'anic inscriptions, it is the very moving and romantic memorial of Shah Jahan, who never remarried, to his beloved wife Mumtaz Mahal, who had died in childbirth during the delivery of her fourteenth baby. What could be more human? A glance at the drawings and sketches here underscores this humanistic concern. It is expressed forcefully and directly by the artists, whose innocent and clear-eyed approach brings to mind experiences common to travelers in India—the episodes on trains or buses in which the Indian in the next seat looks one in the eye with most friendly curiosity and fires questions of startling intimacy. He or she wants to know *all* and *at once*. So did the Indian artists and patrons search for truth. Some of their findings, about people, animals, birds, and gods are now assembled before us. If only we could experience them as intensely and deeply as they did!

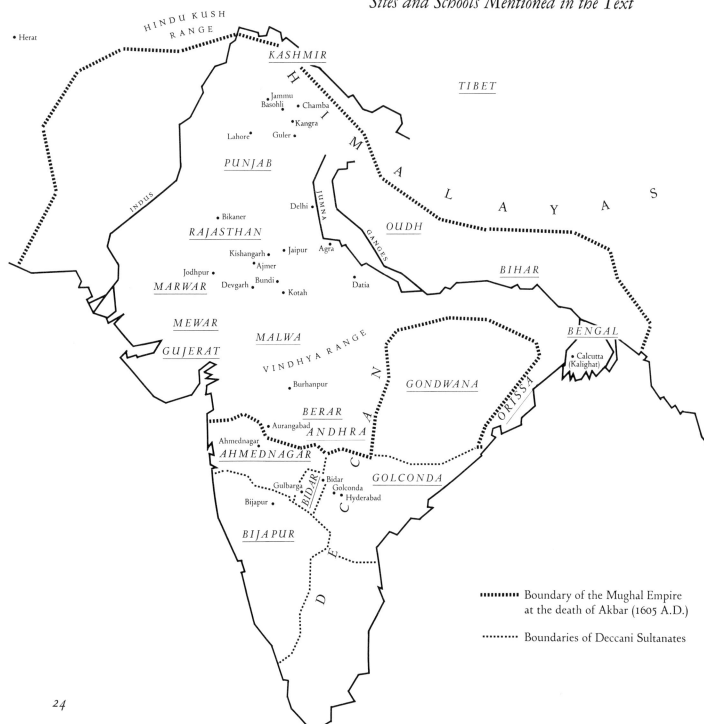

INDIA

Sites and Schools Mentioned in the Text

CENTRAL ASIA

• Bukhara • Ferghana
 • Samarkand

• Herat

HINDU KUSH RANGE

KASHMIR

TIBET

H I M A L A Y A S

• Jammu
Basohli • • Chamba
 • Kangra
Lahore • Guler •

PUNJAB

INDUS

Delhi • JUMNA

• Bikaner

RAJASTHAN

OUDH

GANGES

BIHAR

Kishangarh • • Jaipur Agra •
 • Ajmer
Jodhpur • Bundi • • Datia
Devgarh • BENGAL
 • Kotah

MARWAR

MEWAR

• Calcutta
 (Kalighat)

MALWA

GUJERAT

VINDHYA RANGE

GONDWANA

ORISSA

• Burhanpur

D E C C A N

BERAR

ANDHRA

• Aurangabad

Ahmednagar •

AHMEDNAGAR

GOLCONDA

Gulbarga • • Bidar
 Golconda •
 • Hyderabad

BIDAR

Bijapur •

BIJAPUR

D E C C A N

▪▪▪▪▪▪▪▪ Boundary of the Mughal Empire
 at the death of Akbar (1605 A.D.)

········· Boundaries of Deccani Sultanates

24

Catalogue and Plates

Folk and Traditional Art

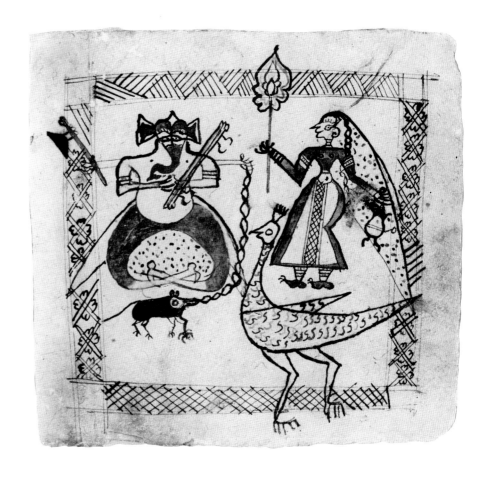

1 *Ganesh*

Rajasthan; dated 1589 A.D.
Black line and color on paper
H. 16.8 cm., W. 18.4 cm.
Inscribed on the back: "I pray to Lord Ganesh.
The book is the work of Doom Chaju's grandson
and the son of Gopala named Dayala and written
by Khatri Kalu at the town of Nagar, whose
ruler is Gopal Dasji; the ruler of Ranthambhor
is Jaggan Nathji, and the emperor of Lahore
is Padshah Akbar; in the year V.S. 1646 (1589
A.D.) on Chaitra, Vade, 11th."
Lent anonymously

Appropriately, the first item in our exhibition is a drawing
of Ganesh, the elephant-headed Hindu god who is wor-
shipped at the beginning of any undertaking. His mantra—
the seed sound used in meditation—is *aum*, which begins

every rite. Standing beside him in this drawing is a woman,
perhaps his mother Parvati, the wife of Lord Shiva, his
father. Beneath him is his vehicle, the mouse, master of the
inside of everything. According to tradition, Shiva became
angry once when Ganesh tried to prevent him from enter-
ing Parvati's house. Enraged, he sent his squires to reprimand
his obstreperous son, whose head was chopped off in the
ensuing fight. Parvati was so distressed by Ganesh's death
that Shiva promised to replace the head with the first one
to come along. He did; and the head happened to be an
elephant's.

Stylistically, this drawing differs little from popular paint-
ings of today. On the folk level, motifs are long-lived. The
sweeping lines of Parvati's scarf and her profile, however,
seem close to the so-called "Chaurapanchasika" style of early
Rajput painting, a factor consistent with the inscription on
the back of the drawing.

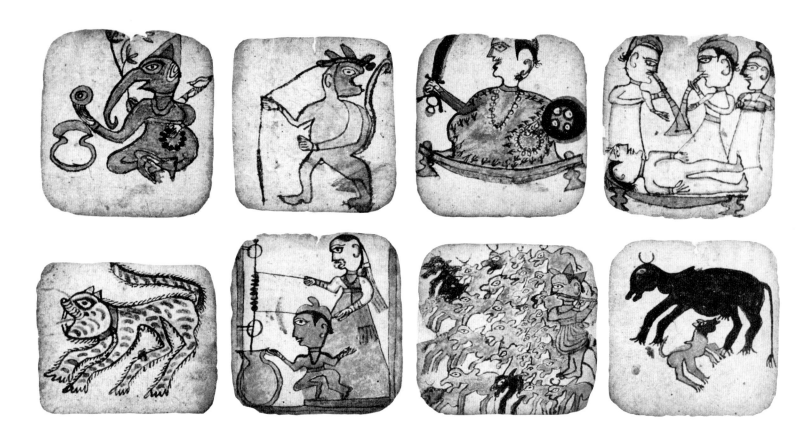

2 *Eight Folios from a Book of Omens* (Sakunamala)
 Punjab Hills, Basohli school (folk style); ca. 1730
 Black line and color on paper
 H. 9.7 cm., W. 9.2 cm. (average)
 Lent by the Jagdish and Kamla Mittal
 Museum of Indian Art

A nonprofessional village artist created this series of eight
folios showing Hanuman the monkey god, Krishna fluting,
the infant Krishna stealing butter, a tiger, Lord Ganesh, a
sick man attended by horn players, an enthroned Raja, and a
cow with a calf. In spite of his lowly technique and training
(or lack of it), the artist should be ranked as a "master." He
drew firmly and directly, with total confidence, creating
images of magical impact. Originally, strings were attached
to each folio of the series, which can be likened to our sets
of Tarot cards. The person whose fortune was to be read
chose a string and pulled it, and the attached card was then
interpreted.

3 Rama's Battle Wagon

South India, southern Andhra; mid-18th century
Black line and color on paper
H. 20.7 cm., W. 14.7 cm.
Lent anonymously

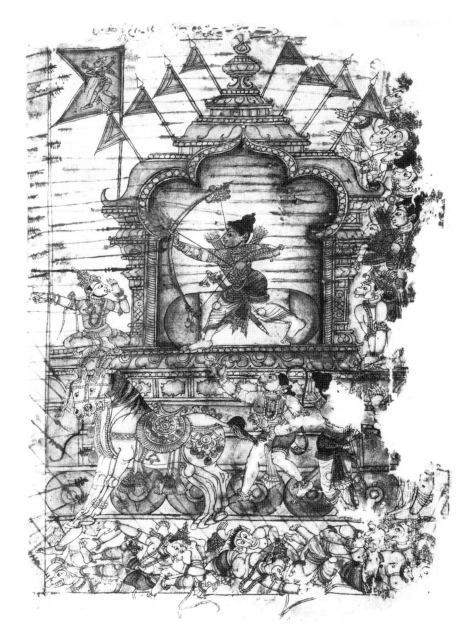

Indigenous Indian styles survived longer in places removed from Mughal and European influences either through geographical remoteness or because their inhabitants were too humble to share the innovations of higher culture. In the south, protected by distance, traditional Hindu styles exist today, supported by very active temples and religious individuals.

Not much is known about South Indian book painting, largely because the manuscripts remain in devout hands. An exception is the incomplete *Ramayana* manuscript in the State Museum, Hyderabad, from which this page may have been separated. Describing the adventures of the hero Rama and his friends, as they wage war against the evil demon Ravanna, the *Ramayana* is one of the oldest and most important Hindu epics. The State Museum manuscript has been studied and published by Jagdish Mittal, who dates it to the mid-eighteenth century and ascribes it to southern Andhra, "probably from Anantapur, Chittoor, Cuddapah, or Nellore districts."[1] The text, consisting of little more than captions to the illustrations, is in Telugu script written on hand-laid foreign paper.

In this picture, arrows zing through the air, wounding and killing many, who pile up at the bottom of the page. Others boldly shoot arrows or find shelter behind the wagon's housing. The expressions of the human and monkey heroes are varied and acute; some are intrepid, others justifiably anxious. A highly skilled professional artist has combined reverence with humorous worldly observation.

1. Jagdish Mittal, *Andhra Paintings of the Ramayana* (Hyderabad, 1969), p. 36. See also: C. Sivaramamurti, *South Indian Paintings* (New Delhi, 1968).

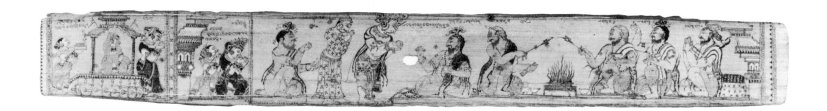

4 *Two Folios from the Romance of Chandrabhanu and Lavanyavati*

Eastern India, Orissa; early 19th century
Incised palm leaves with ink and color
H. 4.6 cm., W. 41.6 cm. (each)
Lent anonymously

These folios from a palm leaf manuscript were drawn by incising the lines with a sharply pointed stylus, then rubbing pigment into the scratches. Although they date from the nineteenth century—as can be seen from the costumes—they are almost as traditional in style as in technique, which could have been used as early as the twelfth century. The settings are extremely simple and the characterizations, while bristling with life and humor, conform to long-standing canons. The first folio shows three noble warriors readying their swords at the left and, on the right, a nobleman inspecting his wardrobe. The second illustrates a prince visiting holy men, who perform a rite while his bride and her attendants await.

Although these pictures were drawn in Orissa, on the central east coast of India, the style is related to traditional pictures and shadow puppets from as far away as South India and Rajasthan, all of which can be seen to stem from an ancient Pan-Indian mode. Distinct from the lower levels of folk art (represented by Nos. 1 and 2), pictures such as these are survivals of motifs and techniques handed down through many, many generations of professional artists who obviously took pride in maintaining the purity of their heritage. Like musicians trained in a particular repertoire, they performed with few improvements, making occasional concessions to the passage of time by incorporating up-to-date costumes and weapons.

Other folios from this manuscript are in the collection of George Bickford. See: W. G. Archer and Stanislaw Czuma, *Indian Art from the George P. Bickford Collection* (Cleveland, 1975), no. 132.

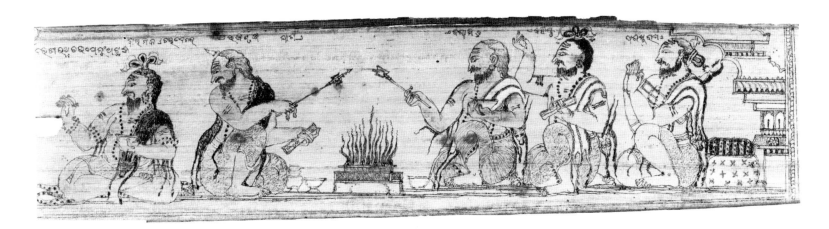

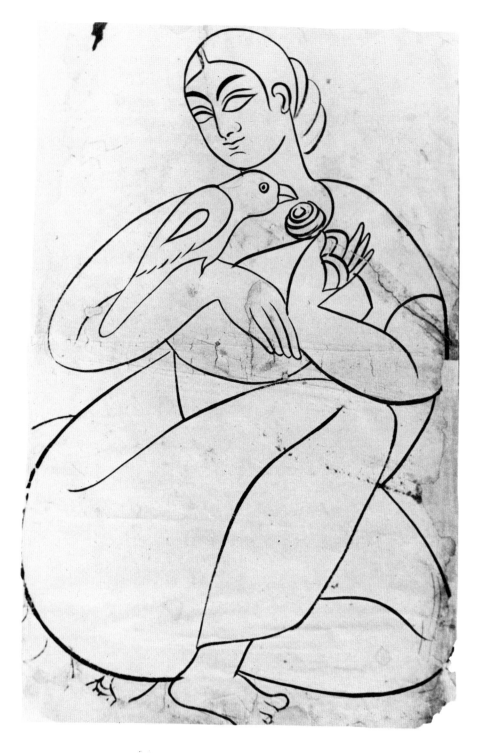

5 *Woman and Parrot*
Bengal, Kalighat school; ca. 1875
Black line on paper
H. 45 cm., W. 29 cm.
Lent by the National Museum, New Delhi

Kalighat paintings and the far rarer drawings were ephemera made to sell as cheaply as possible to pilgrims and tourists at the shrine of the goddess Kali ("the Destroyer") in Calcutta. They were turned out in large quantities by families of artists, sometimes working in assembly lines comparable to those used by pottery painters. At best, as here, these humble, anonymous painters developed splendidly assured brushwork, with the particular knowingness that comes from repetition.

Although the paintings were ordinarily religious in subject, secular themes, usually based on local politics, scandals, or other saleable subjects, were occasionally adjusted to the Kalighat artists' repertoire. The woman with her parrot may represent a popular local courtesan, though her unindividualized features also link her to the ancient line of voluptuous women in Indian art.

An almost identical drawing was published by Stella Kramrisch in *Unknown India: Ritual Art in Tribe and Village* (Philadelphia, 1968), pl. XXXIV. For Kalighat painting, see: W. G. Archer, *Kalighat Paintings* (London, 1971).

Published: O. P. Sharma, *Indian Miniature Painting* (Tokyo, 1973), no. 98.

Mughal Art

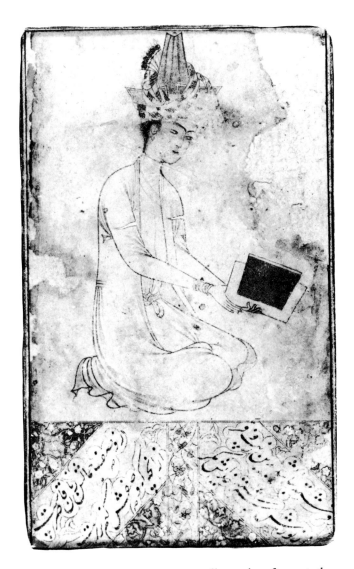

6 A Kneeling Courtier
Attributed to Mir Sayyid 'Ali
Mughal; mid-16th century
Black line with gold and color on paper
H. 8.5 cm., w. 5.2 cm. (sight)
Lent anonymously

"How un-Indian!" viewers might well exclaim, but one of the truisms about India is that everything and anything happens there. All the same, this small, courtly, markedly Iranian portrait comes as a surprise, until we learn that it was created by an Iranian artist who joined the Mughal court of Humayun.

Babur, the founder of Mughal India and father of Humayun, had invaded India in 1526. Since he was descended from both Chinghiz Khan and Timur, his was a conqueror's blood. His life began badly as he was a princely orphan with few followers and almost no domain, but he was eager and intelligent, with a remarkable flair for overcoming bad luck. More than a soldier of fortune, Babur was a notable author, whose memoirs offer history at its most immediate and lively. His prose reveals him as a deeply human, poetically inclined lover of nature, who delighted in planning gardens and studying wild life, enthusiasms that were inherited by his imperial descendants, who ruled most of India until the last Mughal emperor was removed from the throne by the British in 1858.

After only four years as "emperor" of the Mughals, rather a large word under the circumstances, Babur died in 1530. His son Humayun inherited a troubled and vulnerable kingdom, which he failed to hold against Sher Shah, an Afghan nobleman of Bengal, who defeated the Mughals in 1540.

Forced to flee, Humayun eventually took refuge at the Safavid court of Iran, where he was offered sanctuary by Shah Tahmasp. Indeed, the Shah not only promised him military aid for the retaking of Hindustan, but also refrained from interfering when Humayun invited several of the Shah's artists (Mir Sayyid 'Ali, Abd as Samad, and Dust Muhammad) to join his entourage. Humayun was putting his stamp on the character of Mughal art, for of these three major artists, the first two were probably the most naturalistically inclined of all the masters at the Safavid court.

It would be impossible to say exactly when this small portrait of a kneeling prince was created, but it is the earliest

known Mughal drawing. Its true portrait character already reveals Mughal characteristics, and the prince's turban is typical of the Humayun period. Presumably the drawing was done at Kabul, sometime after 1549 when the Iranian artists joined the Mughal court. Painting workshops were certainly established in Kabul, which was the Mughal capital most of the time until Humayun's triumphant return to India in 1555.

Comparison with signed or reliably attributed pictures suggests that the drawing is by Mir Sayyid 'Ali, whose tightly perfect brushwork is recognizable in the flower-like hands, graceful arcs of the sleeves, and supremely elegant pose.[1] The verses below, on the same paper, are probably also his. As a poet, Mir Sayyid 'Ali was known as Judai ("the Loner"), a *nom de plume* perfectly suited to his temperament. The verses are intended to laud the sitter:

> There is no angel with this beauty and
> As if God had created him from light
> The tongue is helpless in describing his beauty.
> He is above any description I give of him.

These lines were probably intended to please Emperor Humayun as well, for more than likely they refer to Shah Abu'l Ma'ali, Humayun's adopted son and fanatical favorite, whose checkered career included moments of heroism, a horrifying murder, and childish vaingloriousness. Ultimately he was strangled in 1564 by order of Mirza Hakim, brother of Humayun's successor, Akbar.

For Shah Abu'l Ma'ali, see: Ishwari Prasad, *The Life and Times of Humayun* (Bombay, 1955). An inscribed portrait of Abu'l Ma'ali is in the collection of Prince Sadruddin Aga Khan.

1. For a closely related drawing done at Tabriz, see: F. R. Martin, *The Miniature Paintings and Painters of Persia, India, and Turkey* (London, 1912), vol. 2, pl. 107. A fuller account of Mir Sayyid 'Ali will be found in Martin Bernard Dickson and Stuart Cary Welch, *The Houghton Shahnameh* (Cambridge, forthcoming).

7 *A Learned Man*

Attributed to Basawan
Mughal; ca. 1575–80
Black line with color washes on paper
H. 18.7 cm., W. 13.6 cm. (sight)
Lent anonymously

Humayun died in 1556, leaving his son Akbar the Great (r. 1556–1605) a precarious legacy. The new emperor was fourteen years old, hardly an age to rule, even in a solidly established kingdom. Fortunately, the Afghan ruler who had forced Humayun into exile was an administrative genius whose system of government was adopted; and Akbar's regent, Bairam Khan, was an able soldier as well as statesman. Best of all, Akbar was a demon of energy, with unfailing intuition. Almost at once, he undertook to enlarge his kingdom by military conquests and, whenever possible, to convince the conquered to join in his vision of empire.

Akbar's unorthodox views in almost every field enabled him to bring together formerly inimical religious and ethnic elements. A Muslim, he married into Rajput families (Hindus) and urged his wives' fathers and brothers to become leaders in his army. Inasmuch as soldiering and governing were their caste occupations, this arrangement was often extremely successful. In order to promote understanding of the Hindus among the Muslims, Akbar ordered translations of Hindu epics into Persian. Often these were illustrated by his growing school of artists; for whenever the emperor conquered a new area, he hired the leading artists, craftsmen, musicians, or other men of talent to come to his court.

At the capital, these "recruits" were trained by the Mughal masters. In painting, Humayun's Safavid artists, Mir Sayyid 'Ali and Abd as Samad (see No. 6), were the leaders whose task it was to create a synthesis from all the styles brought together at Akbar's court, beneath the ever-watchful eye of the young emperor himself. Akbar's intensity and range of interests, as well as his practical effectiveness, made him a supremely creative patron in every area he touched. Although he could neither read nor write (or so the claim goes), he was a leader among philosophers, poets, scientists, musicians,

theologians, and artists. As a boy he studied drawing with
Mir Sayyid 'Ali, and one of his habitual pleasures was seeing
the weekly or even daily productions of his artists, of whom
there were more than a hundred masters, not to mention
pupils.

One of the pupils who came early to Akbar's court was
Basawan, a Hindu of genius, who painted this corpulent
Sufi, or scholar. Probably trained by Abd as Samad (see No.
10), Basawan soon became one of the leading Mughal paint-
ers, if not the single most instrumental figure in the creation
of a truly Mughal style. This portrait excludes all Iranian
graces—which Akbar disliked, it seems—and concentrates
upon revealing as much as possible of the sitter's personality.
The scholar looks noble, powerful, and as earthy as a potato,
the bulbous shape of which he somewhat resembles, for early
Akbar period pictures such as this have the aspect of rugged
natural forms. Every detail here, from the conveniently
tethered cat to the water pot, pillows, scroll, and writing
box, seems imbued with the breath of life. Even the sitter's
scarf twists like a snake.

This drawing was part of an album assembled in 1611/12
for the nineteen-year-old Prince Khurram, who became
Shah Jahan, the builder of the Taj Mahal. On the back of
the folio there is a long inscription in the hand of the young
prince, which includes passages he copied from his father
Jahangir's inscriptions in books in the royal library. The
panels of unusually free and lively arabesque ornament are
probably contemporary with the drawing.

Cf. Stuart Cary Welch, "The Paintings of Basawan," *Lalit Kala* 10
(1961), fig. 1. For another comparable Mughal portrait, see: Friedrich
Sarre and Eugen Mittwoch, *Die Zeichnungen von Riza 'Abbasi* (Munich,
1914), pl. 48,B. The latter drawing is now in the Freer Gallery of Art.

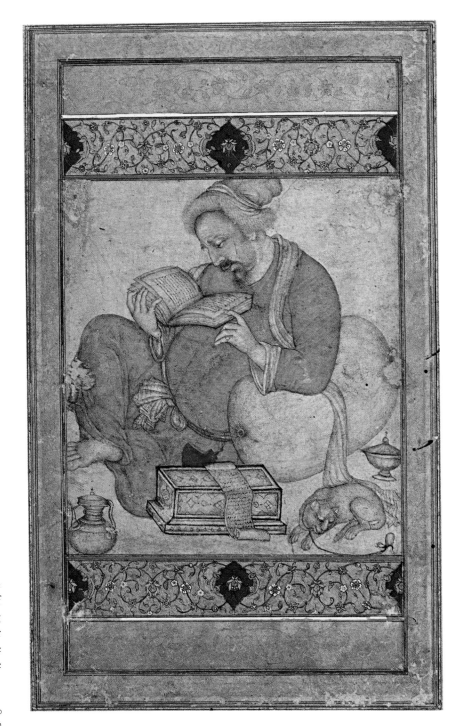

8 *A Miserable Horse, Man, and Dog*

By Basawan
Mughal; ca. 1585–90
Black line and washes on paper
H. 27 cm., w. 36.5 cm.
Lent by the Indian Museum

This profound, painful drawing provides an antidote to the popularly held view that Mughal art is all richness and elegance. Here Basawan has created one of the most memorable variations on a theme frequently encountered in Iranian and Indian art, the wasted nag (see also No. 34). Basawan's interpretation of the starving animal, with each bone, sinew, and scraggly hair accosting our eyes, is almost unbearably convincing. The wretched groom, carcass of a hound, and bleak landscape setting are Basawan's original contributions to the subject, as is the fleet fox, whose contrasting healthiness intensifies the exhaustion of the others and spares us from unrelieved gloom.

A later Mughal poem, by one of Shah Jahan's court poets, Abu-Talib Kalim, provides a humorous description of such a nag. It has been translated by Professor Wheeler Thackston as follows:

ON HIS IGNOBLE STEED

O God, that horse you have put on the road is so weak
 it could never go against the wind.
So covered with its own sweat, it is a boat in water
 fixed in one place by the anchor of the stirrup.

To go one pace it takes an hour.
Its veins stick out over its body like lines on a calendar.
It is so shy and afraid of the road
 it thinks the crooked lane is a snake.
Had Plato not seen my horse,
 he would have never audaciously
 proclaimed the world to be so ancient.
A consumer of fodder, a waste of space,
 unresponsive and refractory.
No one learns anything beneficial from such a horse.
When it lifts its head from the fodder-bag,
 it sits down on its ass.
You'd say Kalim had mounted a pestle.
It has received scourging from God's creation
 to the extent that its head precedes its tail.
Its neck is as thin as the bridge of Sirat.
Like people on the Day of Resurrection,
 quivering from fright, are the hairs of its mane.

(*Qit'a* XXXI)

The author is grateful to Dr. Asok Kumar Das for having called his attention to this Mughal masterpiece.

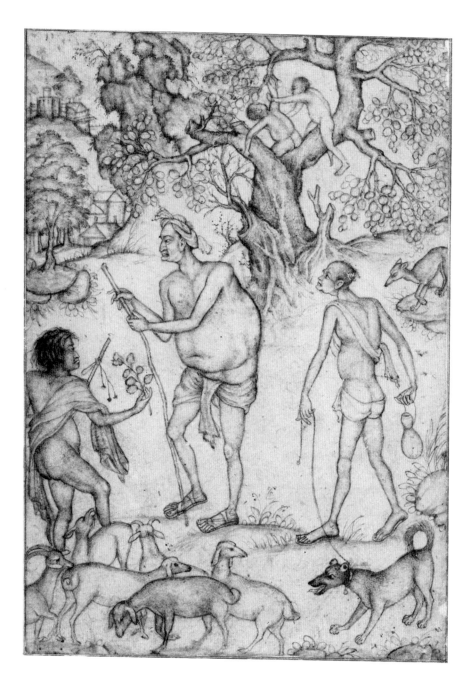

9 *Dervishes*

Attributed to Basawan
Mughal; ca. 1585–90
Black line and washes on paper
H. 18.5 cm., W. 12.7 cm.
Lent by the India Office Library and Records

Both Akbar the Great and Basawan had a taste for holy men. On the basis of this artist's drawings and paintings of them, the emperor's attitude can be seen to have ranged from deep respect to good humored amusement at their odd shapes and antics. In this picture, Basawan looked upon a pair of roaming dervishes with an eye peeled for eccentricities. The nutcracker-jawed senior, offered a flower by a shepherd lad of equally peculiar mien, is about to lose his breech clout, which sags beneath a hugely distended paunch. A pace behind, leading their barking dog, strides the follower, who gazes reverently at his master. In the background two more nude figures play in the branches of one of Basawan's characteristically "baroque" trees, in which the boughs twist and interpenetrate with almost as much life as the artist has given the dervishes.

Basawan, the most psychologically acute of Akbar's artists, may well have originated what might be termed the conversational portrait, in which two people are studied together, each bringing out the other's personality. Rare in other traditions, this type of portrait remained a fixture of Mughal art until the late seventeenth century (see also No. 20). The device avoids the frequent self-consciousness of the single sitter and adds vitality, psychological depth, and credibility—all factors of great moment to Akbar.

Published: Leigh Ashton, ed., *The Art of India and Pakistan* (London, 1949), no. 746.

10 *A Prince Resting Under a Tree During a Hunt*
Attributed to Abd as Samad
Mughal; ca. 1585–90
Black line with gold and slight color on paper
H. 22.8 cm., W. 15.8 cm.
Lent by Prince Sadruddin Aga Khan

This is the only fully elaborated drawing we have seen by
Abd as Samad, one of Humayun's imported Iranian artists
who was also one of the leading painters in Akbar's employ.
According to Akbar's confidant and biographer Abu'l Fazl,
writing in the *Ain-i-Akbari* ("The Mode of Governing"),
"Abd as Samad was styled *Shirin Qalam*, or 'sweet pen.' He
comes from Shiraz. Though he had learnt the art before he
was made a grandee of the court, his perfection was mainly
due to the wonderful effect of a look of his majesty, which
caused him to turn from that which is form to that which is
spirit. From the instruction they received, the *khwaja's* pupils
became masters."[1]

Abd as Samad's work from his youthful Tabriz years can
be recognized in Shah Tahmasp's *Shahnameh* and his artistic
development can be traced over the years to as late as 1594.
One can see very clearly the differences between his early,
Iranian style and that inspired by the emperor's "look." As
might be expected, his pictures for Akbar, such as this one,
are more naturalistic, with little emphasis upon elegant cal-
ligraphic line, and far more upon palpable roundness, par-
ticularly in the drawing of figures, animals, and trees.

Abu'l Fazl's point that through Abd as Samad's teach-
ing his pupils "became masters" is borne out by this draw-
ing, which is in many ways similar to the work of his pupil
Basawan, such as the "Dervishes" (No. 9). Although the
Hindu artist's characterizations are more biting and ex-

Detail No. 10

treme, his sense of form, technique, and treatment of space owe much to the Tabriz master. The border of gold flowers and fully painted birds and animals dates from the second half of the seventeenth century.

For another drawing by Abd as Samad, showing Humayun's favorite, Shah Abu'l Ma'ali, being constrained by Tuluq Khan Qochi, see: Percy Brown, *Indian Painting Under the Mughals* (Oxford, 1924), pl. VIII. For a fuller study of the artist, see: Dickson and Welch, *The Houghton Shahnameh*.

1. Abu'l Fazl Allami, *Ain-i-Akbari,* trans. H. Blochmann and H. Jarett (Calcutta, 1875–1948), p. 114.

11 *Composite Elephant with Demons*
 Mughal; late 16th century
 Black line and slight color on paper
 H. 16.4 cm., W. 22.3 cm. (without borders)
 Inscribed: "Ashraf"; "Sadiq"
 Lent by Mr. Edwin Binney, 3rd

In silhouette a running elephant, this fantastic creature surprises us by being made up of assorted animals, birds, and other motifs. Such feats of imaginative draftsmanship are based upon an ancient, always intriguing idea. Its earliest appearance to our knowledge is in so-called "animal style" art of the first millennium before Christ, though one could perhaps see a yet earlier ancestry in the *t'ao t'ieh* masks of Shang China (?1523–?1027 B.C.). In the Islamic world, *symplegma* of animals appear in twelfth-century stone sculptures from Seljuk Anatolia and in a fifteenth-century drawing from Turkman Tabriz (in the Topkapu Sarayi Museum library, Album H. 2153). Stella Kramrisch has published a fascinating composite elephant from a South Indian wall painting done in the Vijayanagar period at Anegundi, which she dates "not prior to the third quarter of the sixteenth century" (Kramrisch, *A Survey of Painting in the Deccan* [London, 1937], pls. 9, 12a). Sixteenth-century miniatures from Khorasan, nevertheless, are more likely direct prototypes for the creations of Akbar's artists (see: A. K. Coomaraswamy, "Les

miniatures orientales de la collection Goloubew au Museum of Fine Arts de Boston," *Ars Asiatica* 13 [1929], no. 73). Related to this type of composition are the pictures of acrobatic feats in which dancing girls arrange themselves as a camel, elephant, or horse (see No. 48).

While it is easy to cite prototypes for such composite beasts, it is more difficult to explain their meaning. Surely, however, the images concealed within animals and occasionally within rocks or mountains are not mere decoration or amusements for the eye. Rather, they would seem to be visualizations of earth spirits, perhaps of Sufi inspiration. Whatever their significance, they encouraged the artist—and still encourage the viewer—to explore his subconscious responses. "Hidden" grotesques of this sort seem to belong to pre-classic phases of art. By 1600, when Akbar's artists reached their classical moment, such creatures are rarely encountered, and those one finds have lost vitality.

The present example is the most complex and animated we have seen from the Akbar period. Crammed with extraordinary flora and fauna, as well as demons and odd personages, the elephant is set in a delightful landscape complete with a fanciful city in the distance.

For animal style art, see: Emma C. Bunker, C. Bruce Chatwin, and Ann R. Farkas, *"Animal Style" Art from East to West* (New York: The Asia Society, 1970), particularly nos. 70, 117, 118.

Published: Edwin Binney, 3rd, *Indian Miniature Painting from the Collection of Edwin Binney, 3rd: The Mughal and Deccani Schools* (Portland, Ore., 1973), p. 56, no. 31.

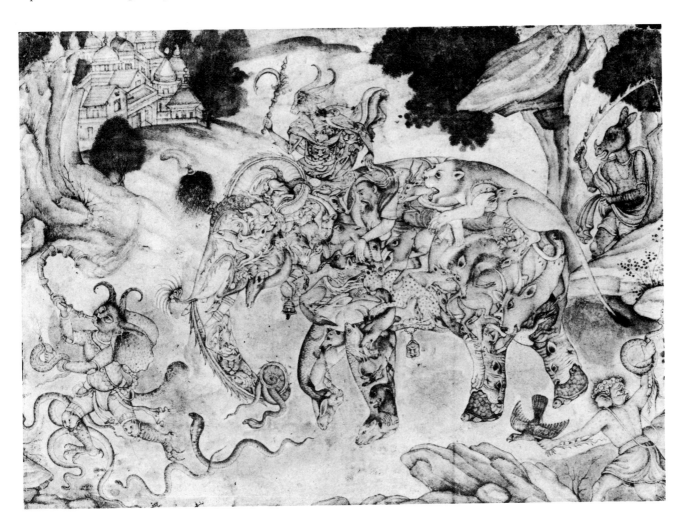

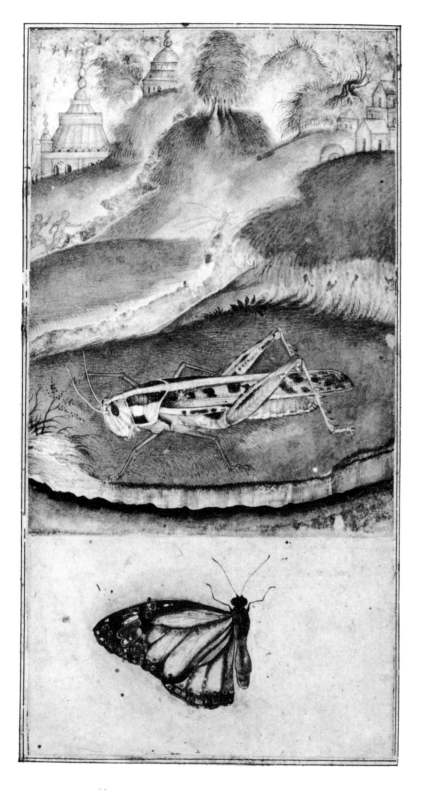

12 *A Locust (and a Butterfly)*

Mughal; ca. 1600
Black line and slight color on paper
H. 17.5 cm., W. 8.9 cm.
Lent by the India Office Library and Records

Asian locusts are far larger, noisier, and more devastating than ours. It is therefore no wonder that one of Akbar's artists was commissioned to make this accurate rendering of one, represented in a desolate landscape. The specimen looms vast in the foreground of the composition, while beyond, several of his companions are sketched busily gobbling up forage. In the distance, two outraged men rush about, not knowing what to do.

Although closely related to grasshoppers, locusts have shorter antennae which do not taper toward the end, narrower wing covers, and shorter, more muscular hind legs. When they are migrating, virtual clouds of them darken the sky. Flying along with a slow, even motion, they create the sound of a heavy shower of rain. When they land, the effect of their appetites is that of a scorching fire, hence their Latin name *locustae*.

This is the only "scientific" insect study of the Akbar period we have seen. Because it was remounted during the eighteenth century as an album page, we can only wonder whether it once illustrated a book on insects, or on other natural phenomena as well. In any event, it exemplifies the penchant for accurate observation of nature which marked Mughal art and thought. It was drawn in the thin, tan washes known as *nim kalam*, a technique favored toward the end of Akbar's reign.

The butterfly, which appears to be somewhat later, was probably added to the page when it was mounted in the eighteenth century.

13 *Album Page of Jahangir*

Mughal; ca. 1615
Black line with gold and slight color on paper
H. 40 cm., W. 24.5 cm.
Lent by the Musée Guimet

Emperor Jahangir, "World Seizer," (r. 1605–27) came to the throne at twenty-seven after the death of his extraordinarily energetic and wise father. Akbar had established a large and mighty empire. Now it had to be maintained, a task for which Jahangir was well suited. Like Babur, Jahangir was a gifted autobiographer, whose memoirs, the *Tuzuk-i-Jahangiri*, are a delight.[1] Written with unflagging gusto, an imperial lack of self-consciousness, and a diarist's concern for significant trivia, the *Tuzuk* was kept sporadically over eighteen years. Here is a sampling of its contents: comments on Jahangir's relationship with his son, Prince Khurram, to whom when pleased he gave the title Shah Jahan, but whose rebellion earned him another, Bi-daulat ("the Wretch"); praise for his Empress Nur Jahan's talents as a huntress, who once shot four tigers "in the twinkling of an eye"; a report of a hermaphrodite cat, said to have sired kittens on one occasion and borne a litter on another; his humane proposal that the imperial elephants be bathed on cold days with warm water; and a description of his monument to a pet antelope named Mansaraj, "which was without equal in fights with tame antelopes and in hunting wild ones."

Jahangir's concern for painting was more intense than Akbar's, and far more connoisseurly. He prided himself upon being able to recognize the work of his master artists in even the smallest details. Agents were constantly pursuing fine miniatures and manuscripts of the past for him, as well as gathering rare objects of art, animals for the royal zoo, and natural curiosities. While his father had seen art

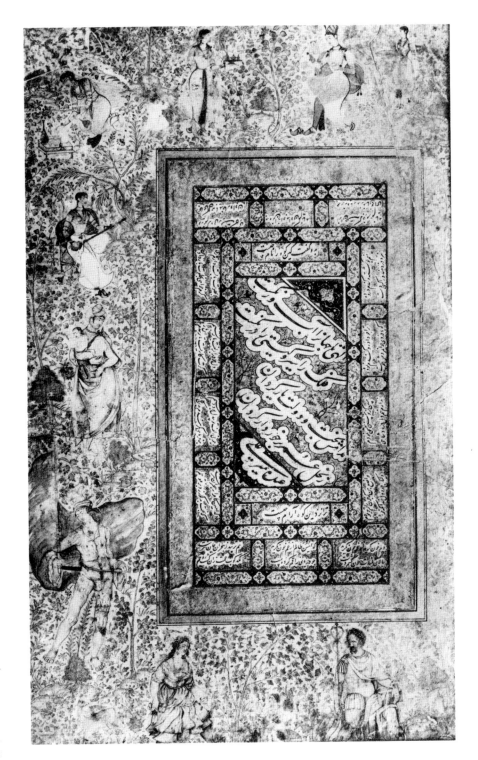

in its relation to the state, employing armies of painters to illustrate official histories of his dynasty and reign, Jahangir maintained far fewer artists and kept them at more aesthetic tasks.

Although his artists continued the tradition of historical painting and illustrated at least one superb manuscript about his life, Jahangir seems to have preferred single miniatures kept in albums. Turning the pages of these noble volumes is thrilling, and surprising, for along with many portraits, they contain remarkably sensitive studies of animals, birds, and flowers, copies from Timurid and Safavid miniatures (as well as originals), and from European works of art.

Calligraphy delighted Muslim patrons, who sometimes valued it even more highly than painting. This folio from an album, most of which belongs to the Berlin State Library, is characteristic of Jahangir's marvels. The superbly written examples of calligraphy were magnificently assembled by a special craftsman, and adorned with small panels of arabesque in gold, lapis lazuli, and other colors. The borders, the basis for its inclusion here, were drawn by one of Jahangir's finest artists, and they include "quotations" from European prints, as well as studies of Mughal and Rajput women. The ensemble would be hard to equal for luxurious beauty.

For another drawing which appears to be by the same artist, see: Stuart Cary Welch, "Mughal and Deccani Miniature Paintings from a Private Collection," *Ars Orientalis* 5 (1963), fig. 10.

Published: Ernst Kühnel and Hermann Goetz, *Indian Book Painting from Jahangir's Album in the State Library in Berlin* (London, 1926), p. 39; Ivan Stchoukine, *Les miniatures indiennes de l'époque des grands Moghols au Musée du Louvre* (Paris, 1929), no. 44, pl. V.

1. Jahangir, *The Tuzuk-i-Jahangiri; or Memoirs of Jahangir,* trans. Alexander Rogers, ed. Henry Beveridge (London, 1909–14), 2 vols.

Detail No. 13

14 *The Himalayan Cheer Pheasant*

By Mansur
Mughal; ca. 1615
Black line and slight color on paper
H. 27 cm., W. 20 cm. (sight)
Lent by the Victoria & Albert Museum

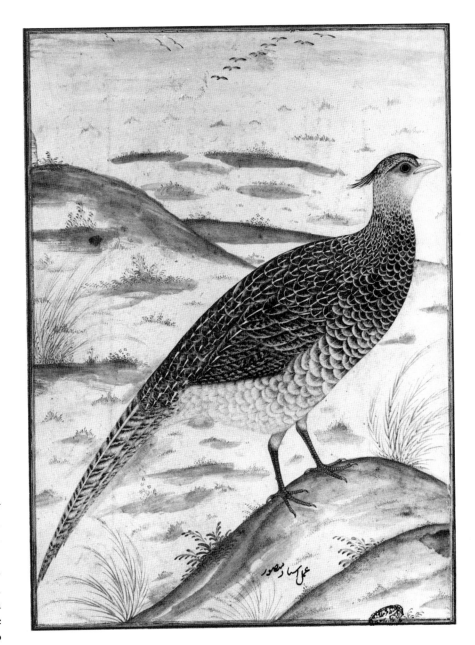

Jahangir's artists traveled with him when the royal household moved to such places as Kashmir. They also accompanied important diplomatic missions in order to bring back the most vivid possible accounts of what happened. When someone or something struck the emperor's fancy, a suitable artist was summoned to make a picture. This proud bird seems to have posed with the dignity of a Mughal nobleman in a rolling landscape ornamented with calligraphic vegetation. The khaki-colored accents have darkened over the years.

Mansur was particularly admired for his bird, animal, and flower studies. In the *Tuzuk*, after praising Abu'l Hasan, his favorite artist, to whom he gave the title Nadir ul-Zaman ("the Miracle of the Age"), Jahangir speaks of Ustad ("Master") Mansur, who "has become such a master in painting that he has the title of Nadir ul-'Asr ["Wonder of the Age"], and in the art of drawing is unique in his generation. In the time of my father's reign and my own these two have had no third" (*Tuzuk-i-Jahangiri*, vol. 2, p. 20).

In another place, the emperor tells of asking Mansur to make a portrait of a falcon sent to him by the Shah of Iran, even though, unfortunately, it had been mauled by a cat en route (ibid., p. 108). Jahangir's descriptions of birds in the *Tuzuk* are frequent, fulsome, and accurate, showing him to have had the talents of an ornithologist. Always curious, and not one for half measures, he was extremely interested in what birds ate, especially since he enjoyed eating them. If, during the cleaning of a bird he had shot, repulsive insects were found in its craw, he admitted his disgust and refused to partake of it.

Published: C. Stanley Clarke, *Indian Drawings* (London, 1922), pl. 16.

15 *A Chameleon on a Branch*

Signed: Ustad Mansur
Mughal; ca. 1615
Black line and color on paper
H. 11.1 cm., W. 13.8 cm.
Lent by gracious permission of
Her Majesty Queen Elizabeth II

(frontispiece)

Jahangir's enthusiasm for Mansur was wholly justified. Painting's Fabre, he combined scientific accuracy with profound artistic sensibility and a hunter's patient zeal.

His chameleon, looming vast as a dinosaur, clutches a springy branch with tiny fingers and a coiled tail, while following an appetizing butterfly with his piercing eye. Every pore, wrinkle, and toenail is recorded with passionate attention that transcends mere accuracy. At his best, as here, the artist so sympathized with his subject that he explored its inner as well as outer nature.

Most of Mansur's pictures can be described as tinted drawings rather than paintings. They seem to have "grown" on the page. Close study of them invites us to share his stroke by stroke revelation of nature's secrets. Although his line was essentially calligraphic and Iranian in flavor, as can be seen here in the foliage, such elegances were forgotten once

he concentrated upon a particular bird, beast, or flower. Among Jahangir's artists, Mansur's color is perhaps the most personal. By slowly building up accents of lapis lazuli, vermilion, or rich green, his otherwise sparely painted miniatures gained brilliance verging on iridescence.

One of Mansur's unique talents was his knack for "catching" the fleeting gesture. Compared to him, most other natural-history artists were still-life painters, who recorded taxidermized specimens in the comfort of their studios. We envision Mansur on all fours, inching his way through a thicket towards his prey, cunning and silent as a cat. If a twig had snapped, the chameleon would have fled, and this miraculous picture would not exist.

Published: Ashton, ed., *The Art of India and Pakistan*, no. 724, pl. 135.

(Shown only at Asia House Gallery)

46

16 *Inayat Khan, Dying*
Attributed to Bishndas
Mughal; 1618
Black line and slight color on paper
H. 9.5 cm., W. 13.3 cm.
Lent by the Museum of Fine Arts, Boston;
Francis Bartlett Donation and Picture Fund

Deservedly the most renowned Mughal drawing, this is perhaps the most sensitive portrayal of a dying man ever made. Inayat Khan, who had been a close attendant of Jahangir, became addicted to opium and wine. When the emperor learned of his illness, he sent one of his own physicians to attend him. Later, when the patient's condition had worsened, Jahangir requested that Inayat Khan be brought to court in a litter. He described the episode in the *Tuzuk*: " 'He was skin drawn over bones.' Or rather his bones, too, had dissolved. Though painters have striven much in drawing an emaciated face, I have never seen anything like this, not even approaching it. Good God, can a son of man come to such a shape and fashion?... As it was a very extraordinary case, I directed painters to take his portrait.... Next day he travelled the road of non-existence" (*Tuzuk-i-Jahangiri*, vol. 2, p. 43).

A painted version of this subject is in the Bodleian Library, Oxford. Due to a mix-up of photographs, it was published instead of this more moving preparatory sketch in *The Art of Mughal India* (New York: The Asia Society, 1963), no. 28. The drawing seems to be by Bishndas, one of Jahangir's most observant portraitists.

For Bishndas see: Asok Kumar Das, "Bishndas," *Chavi: Golden Jubilee Volume, Bharat Kala Bhavan 1920–1970* (Banaras, 1971), pp. 183–91.

Published: Coomaraswamy, "Les miniatures orientales de la collection Goloubew . . . ," pl. 71; A. K. Coomaraswamy, *Catalogue of the Indian Collections in the Museum of Fine Arts, Boston*, part 6: *Mughal Painting* (Boston, 1930), p. 42, pl. XXXII; Eric Schroeder, "The Troubled Image," *Art and Thought*, ed. K. B. Iyer (London, 1947); Richard Ettinghausen, *Great Drawings of All Time*, ed. Ira Moskowitz (New York, 1962), vol. 6, pl. 877.

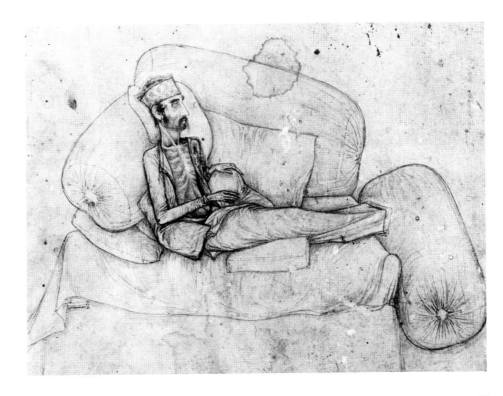

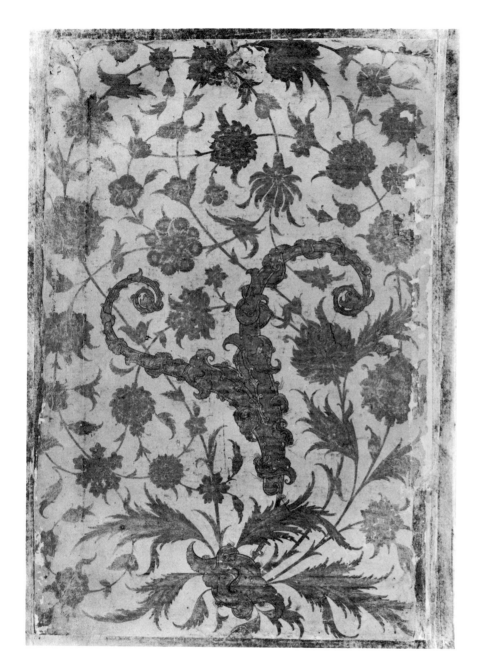

17 *An Ornament in Gold*

Mughal; ca. 1625
Black line and gold on tan paper
H. 30 cm., W. 21 cm. (sight)
Lent by the Victoria & Albert Museum

A powerful splash of gold, this ornament seems more akin to the dynamic Ottoman Turkish designs than to those of the Mughals, whose flowers are usually far calmer and more naturalistic. Here the artist has abstracted the energies and shapes of leaves and blossoms. One can only wonder how and why the design, along with another like it in the Sir A. Chester Beatty Library in Dublin, was created. Perhaps it is an unusually inspired work by one of the special craftsmen responsible for the floral and arabesque borders in royal albums. Suffused with Sufi insight and vision, it must have appealed to the emperor, who included it in one of his most sumptuous albums. The ornament is on the back of a painting of the enthroned Emperors Timur, Babur, and Humayun, each with his wazir, the work of the great master Govardhan, whose career spanned the Akbar, Jahangir, and Shah Jahan periods.

No. 17, verso

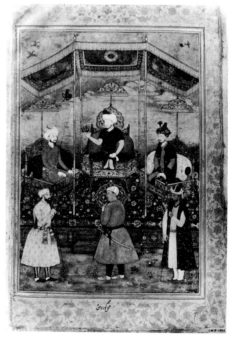

18 *Emperor Jahangir Embracing Prince Khurram*

Mughal; 2nd quarter of the 17th century
Black line on paper, with corrections in white
H. 29.5 cm., W. 20.4 cm.
Inscribed on mount: (*above*) "Picture of the Hall of
Audience at Agra and portraits of Jahangir the
Padshah and of Shah Jahan, on the occasion of Shah
Jahan's departure for Balkh"; (*below*) "Picture of
Jahangir and Shah Jahan, the work of Raja
Manohar Singh."
Lent by the India Office Library and Records

Mughal splendor increased during the reign of Jahangir, along with formality. Here Prince Khurram, who became Emperor Shah Jahan (r. 1627–58), is shown being embraced by his father, a rare happy moment in a relationship that became increasingly strained. The incident took place in 1614 at Ajmer in Rajasthan, after the prince had returned triumphantly from Mewar, where his overwhelming show of force, combined with a famine, had compelled Rana Amar Singh I to be the first of his family to submit to Mughal authority. Inasmuch as the Mewar ruling family was the senior noble house of Rajasthan, this was a proud moment in imperial history. Jahangir's own description of the event is colorful and apt:

"... the prince with great magnificence, with all the victorious forces that had been appointed to accompany him on the service, entered the public palace. . . . I called that son forward and embraced him, and having kissed his head and face, favoured him with special kindnesses and greetings. . . . After this I ordered Khurram to go and wait on his mothers, and gave him a special dress of honour, consisting of a jewelled *charqab* (sleeveless vest), a coat of gold brocade, and a rosary of pearls. After he had made his salutation, there were presented to him a special dress of honour, a special horse with a jewelled saddle, and a special elephant" (*Tuzuk-i-Jahangiri*, vol. 1, p. 277).

This drawing is a preparatory study for folio 42 verso in the *Shah Jahan-nama*, the official history of his reign prepared for Shah Jahan, now in the Windsor Castle library.[1] As such, it sheds considerable light on this problematic manuscript. In its present state, the volume contains forty-six miniatures, all but the first two being full-page in size. Many of them form halves of double-page compositions, a number of which are by different hands and also differ as to

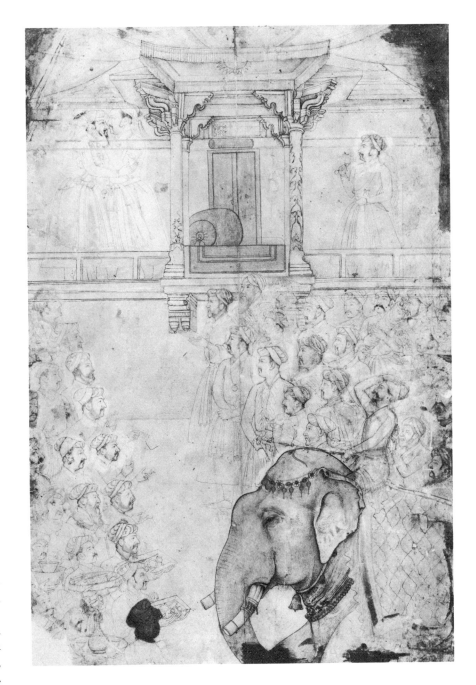

49

immediacy and accuracy, though all of them can be dated to Shah Jahan's reign. At best, the miniatures are by the most talented artists of the royal workshop, and even the least of them are highly accomplished. Some of the miniatures seem to have been done soon after the events they describe, by artist-reporters who had made working sketches of the actual events, while others appear to have been conjured up from rather vague written or even spoken descriptions. Inasmuch as several of the liveliest pages intended for the manuscript are not in it (such as the "Siege of Qandahar" reproduced in Stuart Cary Welch, *A Flower from Every Meadow* [New York: The Asia Society, 1973], no. 66), it seems likely that the artists painted most of the important events of the reign, and then a selection was made for the book when it was assembled at the end of Shah Jahan's reign. This would account for the absence of such unpleasant subjects as the Mughal struggles over Qandahar, which were not to be emphasized in this most sumptuous imperial history.

The India Office drawing is the more finished of two sketches of the same subject; the other, now in the Binney collection, is less elaborate and may be slightly earlier. Inasmuch as the episode took place many years before the *Shah Jahan-nama* was commissioned, in all likelihood this is one of the subjects that had to be reconstructed on the basis of literary descriptions, memory, or incomplete artists' jottings. But since it illustrates one of the few cordial moments in the troubled relationship between Jahangir and Shah Jahan, it was prepared most conscientiously for the manuscript.

The inscriptions on the mount, above and to the side of the drawing, are baffling, as they differ from the identification given in the finished volume. They claim that the scene is Agra and that it shows the royal pair prior to Shah Jahan's departure for Balkh in 1622. This is hard to accept, for according to the *Tuzuk* and other historical accounts, Shah Jahan did not report to his father before he led the imperial armies against Qandahar in 1622. In short, the encounter described in the inscription on the mount never took place.

This inscription, therefore, must be disregarded, unless we can assume that the artist was premature in drawing an expected event that failed to occur(!) and further assume that years later the sketch was used to invent a painting of a different episode! A few bits of evidence tempt one to accept this *outré* theory. Shah Jahan is shown with a full beard and seems older than twenty-one in the drawing; the architec-

ture appears to be at Agra rather than Ajmer; and another inscription on the drawing says it is by Raja Manohar Singh, an unusual but possible name for Jahangir's famous painter who was particularly known for his portraits. On grounds of style, this brilliant drawing might be his work. One must, therefore, maintain an open mind as to its date, pending further evidence.

Published: A. K. Coomaraswamy, *Indian Drawings*, vol. 1 (London, 1910), pl. II; Brown, *Indian Painting Under the Mughals*, pl. LVIII; A. K. Coomaraswamy, "Notes on Indian Painting," *Artibus Asiae* 4 (1927), pp. 292–93.

1. Robert Skelton of the Victoria & Albert Museum and the author are now preparing a full study of the *Shah Jahan-nama*.

19 *Holy Man Meditating*

Mughal; ca. 1640
Black line on paper
H. 19.7 cm., W. 14.3 cm.
Lent anonymously

Portraiture is a major theme throughout Mughal art, probably because the Mughals tended to see paradise as potentially here and now; and in this world people, though hardly on the level of gods and angels, were at least the most important inhabitants. Mughal albums, therefore, are veritable parades of mankind—of princes, courtiers, rival rulers, historical personages, and surprisingly often, of holy men. These other-worldly beings were respected and even envied by royal patrons fated to belong to the worldly life. Akbar's mystical religiosity is well known; Jahangir took pride in preferring religious to political leaders; and Prince Dara Shikoh's interest in Hinduism as well as Sufism could be said to have cost him his life (see No. 21).

This sensitive, razor-sharp study shows a naked yogi, all sinew and bone, in deep meditation. His fingernails have grown so long that they curl like vines. He must have been an ideal model, unconscious of scrutiny and unmoving, reminding us of his rock-carved equivalent in the huge Pallava "Descent of the Ganges" at Mahabalapuram, near Madras. And yet one can imagine him in a different context. His neatly trimmed beard and overall elegance would require only a turban, robes, and a *katar* stuck in his belt to make him acceptable at one of Shah Jahan's formal audiences (*darbars*). One wonders if he was not once a proud Rajput prince, who forsook the worldly life to become a *sannyasi*.

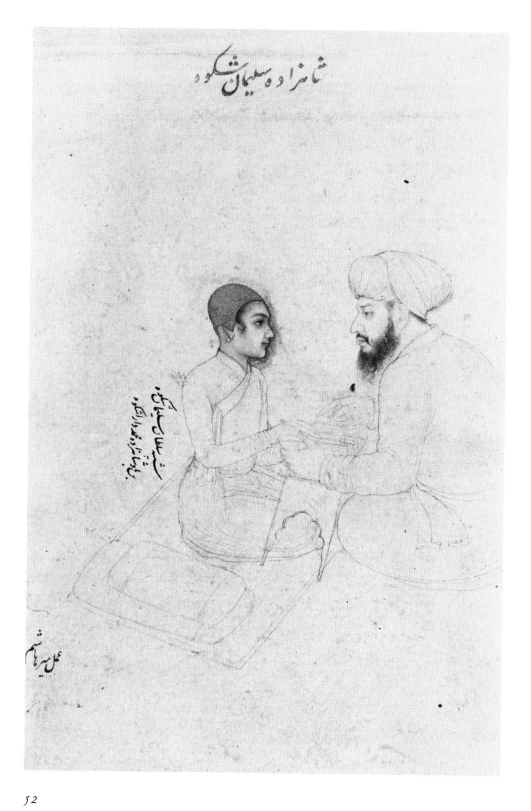

شاهزاده سلیمان شکوه

52

20 *Prince Sulaiman Shikoh with His Tutor*

By Mir Hashim
Mughal; ca. 1645
Black line with gold and slight color on paper
H. 32.5 cm., W. 24 cm.
Inscribed: (*far left*) "Mir Hashim"; (*left of the prince*)
"A picture of Sultan Sulaiman Shikoh, the son of
Prince Dara Shikoh"; (*top*) "Prince Sulaiman Shikoh"
Lent by the Bristol City Art Gallery

Shah Jahan's reign is most happily remembered for the long years of peace, during which the government was so effective that—to use a characteristic image of the time—lambs did not need to fear lions. The Mughal empire had reached a peak of wealth and prestige. Among the arts, architecture was preeminent. Shah Jahan built white marble palaces at Lahore, Agra, and Delhi, several splendid mosques, and the renowned Taj Mahal, erected in memory of his wife, who died during the birth of their fourteenth child. Crisp and immaculate as a jewel, this tomb is also a moving, romantic vision, exemplifying the warmth beneath Shah Jahan's austerity.

Such warmth is also seen in this portrait of Prince Sulaiman Shikoh with his tutor. Sulaiman Shikoh (1635–1662) was the eldest son of Shah Jahan's eldest and favorite son, Prince Dara Shikoh, probably the most appealing but ill-fated figure in all Mughal history. By inclination a poet and mystic, Dara Shikoh spent much of his time with holy men, and like Akbar, he was a free-thinker who admired the good in all religions. He wrote a book on the lives of saints and translated Hindu religious texts. Regrettably, he lived a sheltered life, encouraged to stay near the royal court by Shah Jahan, a father who feared that his own eldest son would be lured, as he himself had been, into trying to seize the imperial power before his time to inherit. But Shah Jahan's effort to protect himself against possible rebellion by Prince Dara took a surprising turn. By indulging and over-protecting his eldest son, he built up animosity, jealousy, and toughness

in another son, Prince Aurangzeb, who imprisoned his father in the fort at Agra from 1658 until his death in 1666. Ironically, Aurangzeb gained the power and experience that enabled him to perpetrate this deed by leading the armies that Dara had not been permitted to lead, power that also gave him the edge in the inevitable wars of succession that lay ahead. Aurangzeb, moreover, was attuned to the spirit of his time, which tended increasingly towards orthodoxy in all matters. While Dara Shikoh's open-mindedness would have appealed to Akbar and earned him success, by the mid-seventeenth century such attitudes were heretical.

Mir Hashim's tender portrayal of the eager young prince and his kindly teacher is a glimpse of Mughal royalty at its most attractive. It can also be seen as representing a late, if not final moment of Mughal civilization at its height. The future of this happy, confident young prince was almost as tragic as his father's. A few years after the defeat and death of Dara Shikoh, he died in the fort of Gwalior, where he had been imprisoned by his uncle, Emperor Aurangzeb. Like many Mughal political prisoners, he was given a daily cup of *pousta*, a drink made from poppy heads crushed and soaked in water. According to Sarkar, "This drink emaciated the wretched victims, who lost their strength and intellect by slow degrees, became torpid and senseless, and at length died."[1] Prince Sulaiman's end came on the fifteenth of January in 1662.

1. Jadunath Sarkar, *History of Aurangzeb* (Calcutta, 1925), vol. 2, p. 235.

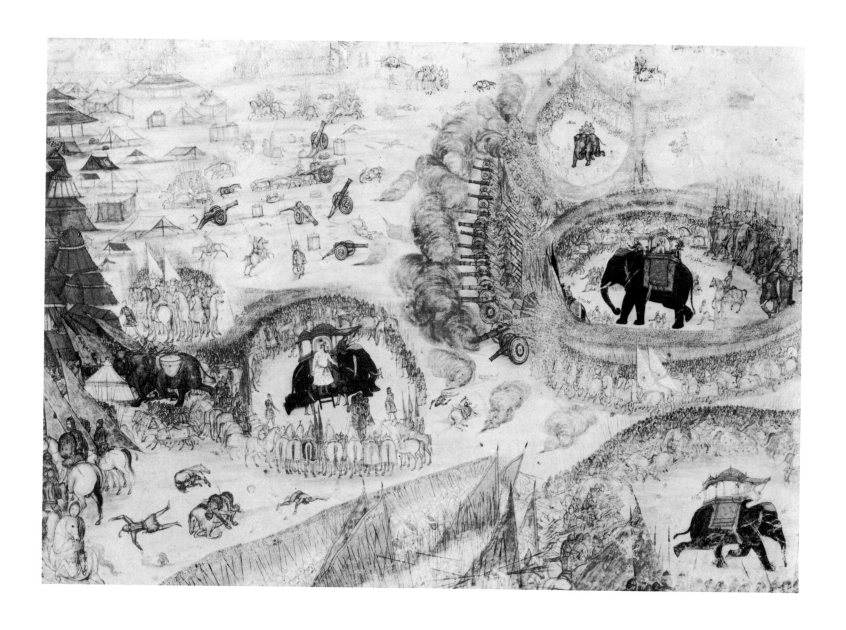

21 *The Battle of Samugarh*

Mughal; ca. 1658
Black line with gold and color on paper
H. 22.6 cm., w. 32.7 cm. (sight)
Lent anonymously

On this sheet of paper, a Mughal court painter drew what seems to be his eye-witness report of Prince Dara Shikoh's second and crushing defeat in the war of succession against his younger brother, Prince Aurangzeb. The first serious set-back had taken place in April of 1658 at Dharmat, where the faulty judgment of Dara's general, Raja Jaswant Singh, played into Prince Aurangzeb's hands (see No. 64). Further supported by his doting father Shah Jahan, in late May Dara raised another army which contemporary gossip claimed was ill-trained and made up of shopkeepers and other un-military types. Whatever the army's quality, Dara's luck had run out. During the course of the battle, his elephant was wounded. The prince dismounted, and this was interpreted as a signal of defeat by his followers, who fled. Dara returned to Agra, where Shah Jahan equipped him for further flight. By the time Aurangzeb reached the imperial fort to see their father, Dara had escaped towards Sind. In an act that must have seemed prophetic, Shah Jahan presented Aurangzeb with a special sword known as *Alamgir* ("Seizer of the World"). The victorious prince assumed this name as his official title when he became emperor.

The unfortunate Dara was captured in Sind and returned to Aurangzeb, who went through the formality of discussing his fate with the religious and other dignitaries of the empire. On the grounds that he was a dangerous heretic, Dara's execution was ordered. It was carried out in old Delhi in August of 1659.

This tinted drawing carries on the tradition of historical reportage known from the illustrations to the *Akbar-nama, Jahangir-nama,* and *Shah Jahan-nama*. Although the horseman at the lower left seems to have been cribbed from a European print of St. George (here without his dragon), and the minutely drawn horsemen in the distance resemble those in the prints of Stefano Della Bella (1610–64), this is probably a very accurate description of the battle. The names of the principal leaders are written near their representations: left, dismounting from his wounded elephant, Dara Shikoh; right, Prince Aurangzeb; lower right, Prince Murad Bakhsh.

Detail

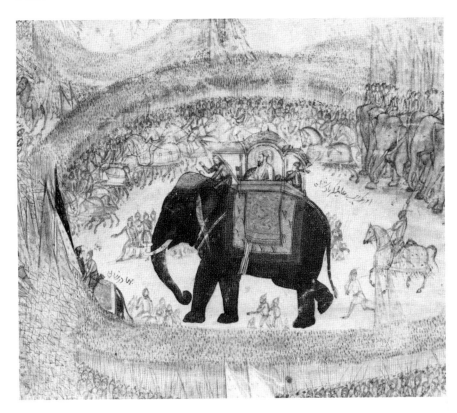

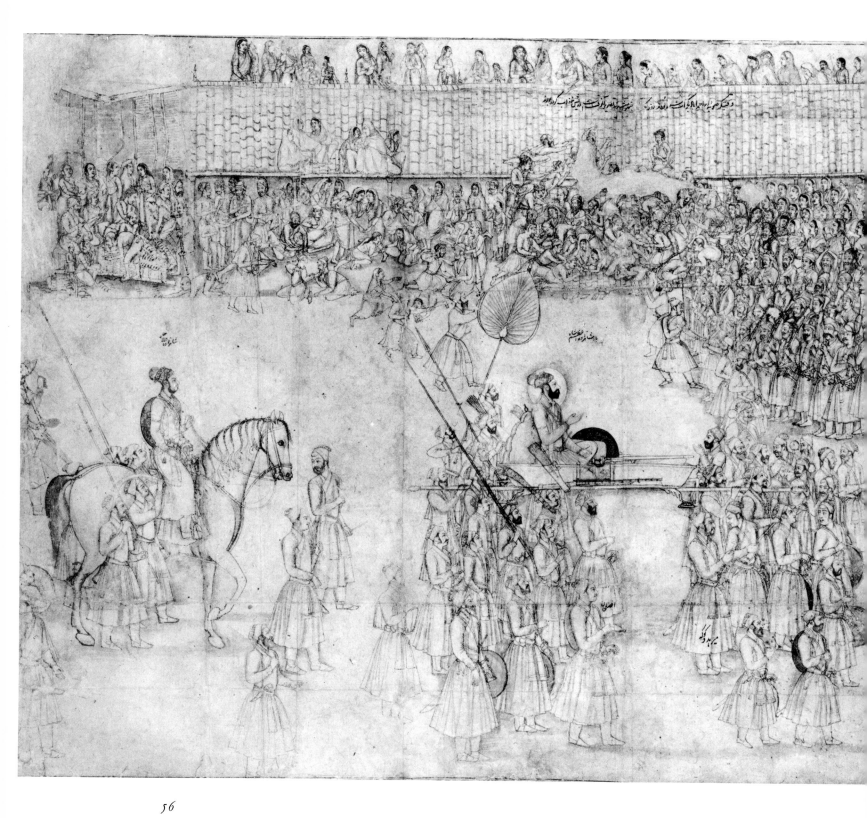

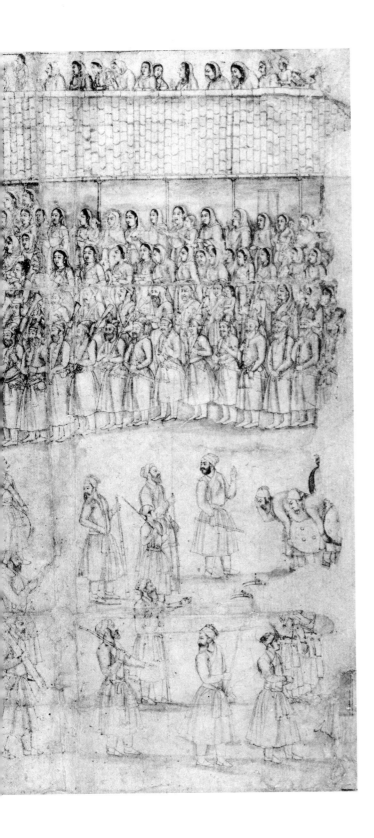

22 *Prince Azam Shah Enters Ahmedabad*

Mughal; ca. 1701
Black line with gold and color washes on paper
H. 35.6 cm., w. 62.2 cm.
Inscribed: (*above litter*) "Prince Azam Shah";
(*above horseman*) "Exalted Prince"; (*on roof*) "When
he became Governor of Ahmedabad in Gujerat,
he entered the city. This is a picture of that time.
They had . . . (word illegible)."
Lent anonymously

India is a land of parades, which range from processions of
naked *sadhus*, or of wagons bearing sacred images, to funerals
and weddings. The Mughals, like the Romans, delighted in
panoply. When Aurangzeb's third son Azam Shah was made
governor of Gujerat in 1701, his formal entry into the city
of Ahmedabad was recorded by a talented artist, who not
only gave us splendid formal portraits of the prince and his
son, presumably the eldest, Bidar Bakht, but also recorded

the cheering and groveling mobs of the city. Beneath the eyes of more distinguished citizens lined up on the rooftop, many scramble for the coins hurled into the street as part of the celebration.

Prince Azam remained governor of Gujerat until 1705, after which, in the absence of a royal governor, the state was vulnerable. Sensing this weakness, the hard-headed Marathas from the western Ghats attacked, led by Dhana Jadav. They successfully held Gujerat until the arrival of

Prince Bidar Bakht, as governor, on July 30, 1706. But peaceful times were soon over.

After the death of Aurangzeb in 1707, a war of succession followed, recalling the terrible battles of Aurangzeb against his brothers. In this new struggle, both Azam Shah and Bidar Bakht were slain at the battle of Jajowan, between Agra and Dholpur.

See: William Irvine, *Later Mughals* (Calcutta, 1922), vol. 1, pp. 22–35; Sarkar, *History of Aurangzeb*, vol. 5, pp. 429–32.

Detail No. 22

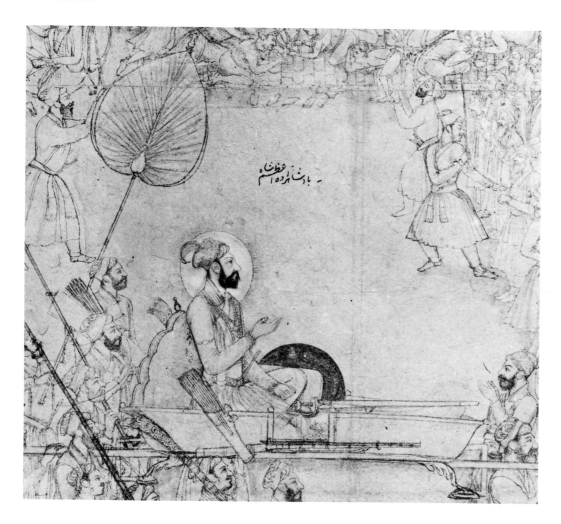

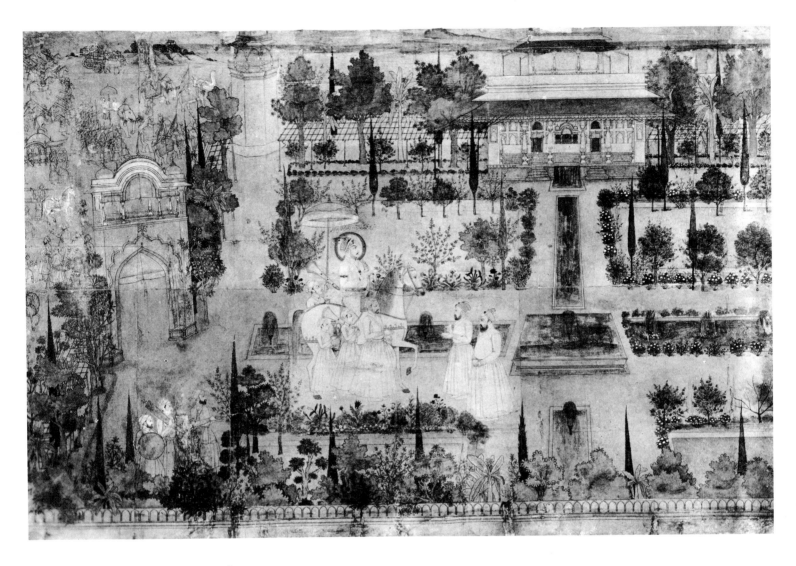

23 *Muhammad Shah in His Garden*

Mughal; ca. 1735
Black line with color washes on paper
H. 53 cm., W. 86.5 cm.
Lent by the Museum of Fine Arts, Boston;
Bartlett Fund and Special Contribution

Muhammad Shah (r. 1719–48) and his wazir Qamr-ud-Din Khan, here standing directly in front of the emperor's horse, challenge historians, who alternately rebuke them as weak, lazy, pleasure lovers and honor them as the last Mughal rulers worthy of the empire. Muhammad Shah came to the throne at seventeen, a handsome, solid, intelligent young man. Gradually the imperial pleasures fattened, weakened, and addled him, until he was barely able to leave the palace. Sex, opium, and wine were his irresistible temptations; music, poetry, witty conversation, and gardening his less criticized diversions. (Floral excesses are permitted by even the most puritanical historians and critics.) Eventually, sated and perhaps exhausted by the worldly life, the emperor spent most of his time with holy men, and it became fashionable at court to ape their manners and dress.

By 1719, the Mughal empire had decayed to such an extent that one can hardly blame Muhammad Shah and his

advisers for avoiding reality. When a province was seized or a battle lost, the emperor took to his gardens and his wazir took to the hunting grounds. Here, we see a still youngish Muhammad Shah riding his ornamented horse through the largest walled garden known from any of his pictures, perhaps situated at Loni, not far from the Red Fort at Delhi. The portrayal gives ample evidence of his enthusiasm for trees and flowers, arranged formally, with elegant ponds, gateway, octagonal tower, and pavilion. The latter somewhat resembles the *Sawan* in the Red Fort, a delightful white marble edifice with a deep reflecting pool, set with many small niches to contain flowers by day and lamps by night. A vicarious stroll through all this increases our sympathy for Muhammad Shah's choice of a pleasant alternative to any action that might arrest his empire's decline.

In 1739, Nadir Shah, the new Shah of Iran, who acted as the angel of death to both the Safavis and the Mughals, invaded India. He sacked Delhi and carted off everything he could find, including Shah Jahan's Peacock Throne, perhaps *the* symbol of imperial power. At once, upon the Shah's departure, a splendid *darbar* was held by Muhammad Shah and his full court, all of whom acted as though nothing had gone wrong. Perhaps they were right—in any event, the empire survived for over one hundred years until it was officially ended by the British in the aftermath of the Mutiny of 1857.

Muhammad Shah's passion for gardens recalls Babur's identical enthusiasm. His artists, as here, drew some of the most majestic and haunting gardens in Mughal art, pictures that were echoed by provincial Mughal and Rajput artists. Mughal polity had failed, but Mughal art still held sway.

For the history of this period, see: Jadunath Sarkar, *Fall of the Mughal Empire* (Calcutta, 1949), vol. I.

Published: Coomaraswamy, "Les miniatures orientales de la collection Goloubew . . . ," no. 153; Coomaraswamy, *Catalogue of the Indian Collections,* part 6, no. CXLIV, pl. LXIV.

24 *The Poet Hakim Momin Khan*
 Mughal; ca. 1835
 Black line and slight color on paper
 H. 16 cm., W. 11 cm. (sight)
 Inscribed on back with the poet's name
 Lent anonymously

Hakim Momin Khan looks intently at the artist and at us. Looking back at him, we sense his strength, intensity, and pride. The artist has not flattered him, and in many ways this late Mughal portrait is as seriously insightful as earlier examples—no mean appraisal inasmuch as Mughal portraiture ranks with the most profound in world art. In the early nineteenth century, Delhi was still nominally the capital of the Mughal empire, which retained an after-glow of power. It also continued to nurture poets, musicians, and artists. The last emperor, Bahadur Shah II, who was exiled to Burma by the British for his role in the Mutiny of 1857, was himself a poet of distinction. Ghalib, one of the most esteemed of all Mughal poets, wrote verses and letters that brought the story of imperial India to a perfect close.

The subject of this portrait, Momin Khan, was also a poet. A friend as well as contemporary, Ghalib had known him for forty-two years when Momin Khan fell from the roof of his house in 1852, broke his arm, and died a few days later.

Related portraits are in the collections of Dr. Annemarie Schimmel and Dr. and Mrs. Wheeler Thackston. For Ghalib, see: Ralph Russell and Kurshidul Islam, *Ghalib: Life and Letters* (Cambridge, Mass., 1969).

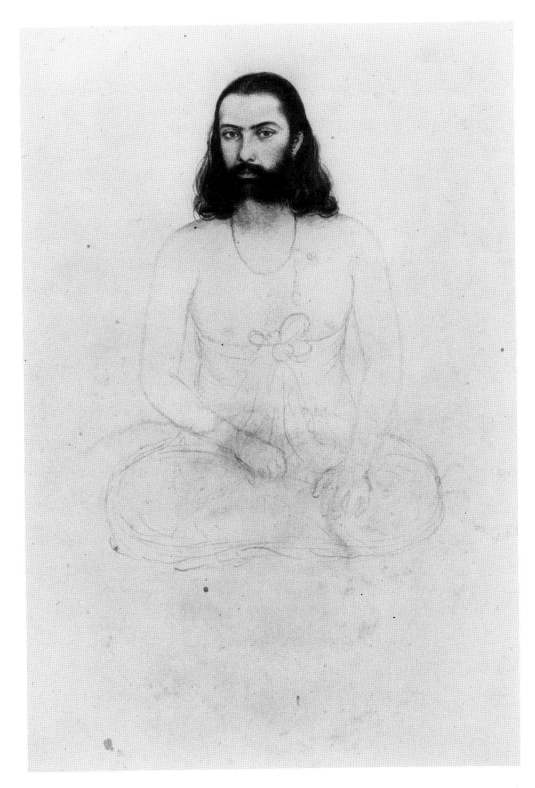

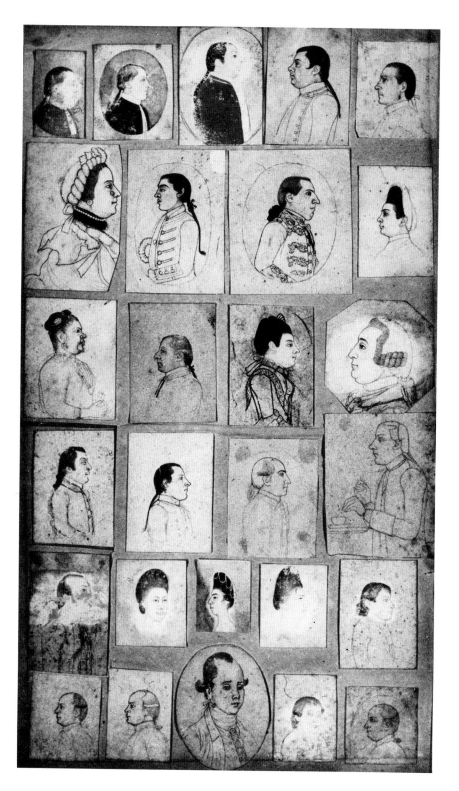

British Indian Art

25 *Twenty-seven Britishers*
 Bengal, Company style; late 18th century
 Black line on paper, with touches of white
 H. 30.4 cm., W. 20.5 cm.
 Lent by the Indian Museum

Like ghosts they haunt us. These are the faces of some of the Englishmen who governed and traded in India during the late eighteenth century. Here they are lined up like so many passport photographs, each abounding with the British characteristics familiar today. Although these "Company" portraits (a term derived from the British East India Company which they served) are "native" substitutes by artists reared in the tradition of Mughal draftsmanship, they are on a par with miniatures made for the British in England since the sixteenth century.

We also know the sitters' types from the memoirs of William Hickey,[1] a lawyer who retired to Scotland in 1808 at sixty, after a long, successful, and often Rabelaisian life centered in Calcutta. His description of British India could hardly be racier or more detailed, although he lost the diaries upon which this labor of his last years was to have been based and had to reconstruct them from memory. Anecdotal as a picaresque novel, the *Memoirs* concentrate upon the pleasurable side of British life in India, a patchwork of drinking contests, dinner parties, carriage races, and assorted love affairs, occasionally marred by the early death of friends, vic-

Details

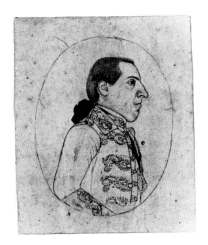

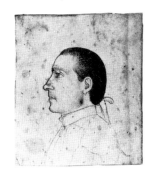

tims of the climate or over-indulgence. Significantly, in a cast of hundreds, there are few Indians. In late eighteenth-century Calcutta and Madras, there were so many British that they scarcely needed to socialize with anyone else. This stands in total contrast to the behavior of such men as James Tod, the somewhat later author of *The Annals and Antiquities of Rajasthan*, whose book includes lengthy but never dull reminiscences of his life with the Rajputs.[2] Unlike Hickey, whose knowledge of Indians seems to have been based upon his acquaintance with servants, prostitutes, and occasional money lenders, Tod became intimately friendly with many Rajputs, whose customs and history fascinated him to such a degree that he wrote the fullest account of them in any language.

Suitably nostalgic photographs of British India are included in Roderick Cameron's *Shadows from India* (New York, 1958), pp. 125–75.

1. William Hickey, *Memoirs of William Hickey*, ed. Alfred Spencer, 4 vols. (London, 1913–25). For an abbreviated, unbowdlerized version, see: Peter Quennell, ed. *The Prodigal Rake* (New York, 1962).
2. James Tod, *The Annals and Antiquities of Rajasthan,* ed. William Crooke, 3 vols. (London, 1920).

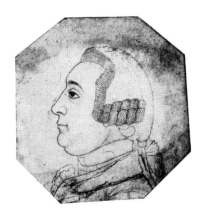

26　*Gingi Vulture*

Calcutta, Company style; ca. 1805
Watercolor on English laid paper
H. 55.2 cm., W. 41 cm.
Inscribed: "Gio"; "Karkas"
Lent anonymously

Although painted for British residents, chiefly members of the East India Company, studies of India's flora and fauna such as this are almost as sensitive and finely executed as those produced for Emperor Jahangir. This watercolor drawing on English paper was made for the distinguished British traveler George Annesley Mountnorris, Lord Valentia, who chose to take his grand tour in the East between 1802 and 1806. It is one of a large series of bird pictures made for him by the artists of Barrackpur, near Calcutta, where the British maintained a menagerie and park and recorded India's flora and fauna for scientific and economic purposes. Although such works of art were not inspired by "artistic" motives, it seems likely that Lord Valentia, as well as the directors of the project, shared the pride of their "native artists" in these lively renderings, which carried on the brilliant Mughal tradition both technically and spiritually.

The Gingi vulture (*Neophron Percnopterus Gingianus*) is more appealing in painted form than in actuality. According to a modern handbook of Indian birds, this "disgusting bird haunts towns and villages, has no fear of man, eats any form of garbage or carrion, and appears mainly to live on human excrement. . . .[Their] nests are most filthy, disreputable structures, a foundation of sticks lined with old rags, wool, earth, or anything else soft that comes to hand, the dirtier the better. . . ."[1]

See: G. Annesley Mountnorris, *Voyages and Travels to India, Ceylon, the Red Sea, Abyssinia, and Egypt in the Years 1802–06* (London, 1809).

Published: S. C. Welch and G. D. Bearce, *Painting in British India, 1757–1857* (Brunswick, Maine, 1963), no. 46.

1. Hugo Whistler, *Popular Handbook of Indian Birds* (London, 1949), pp. 356–57.

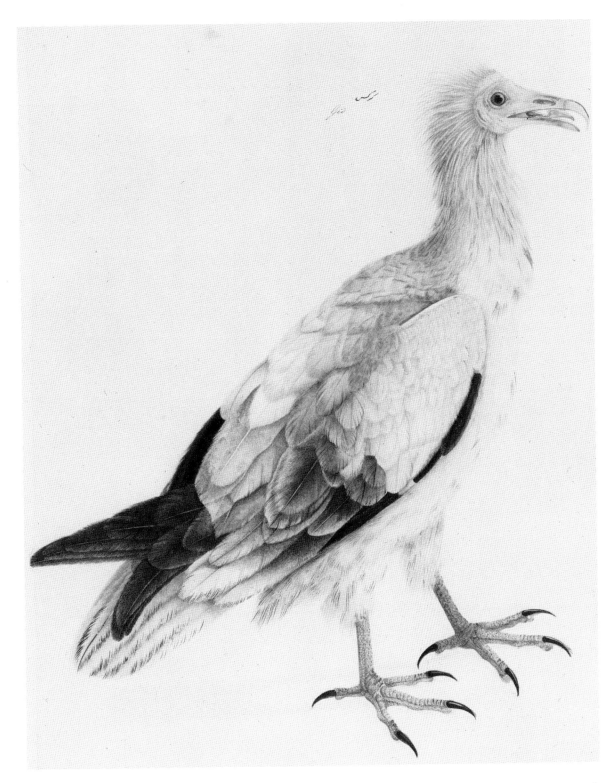

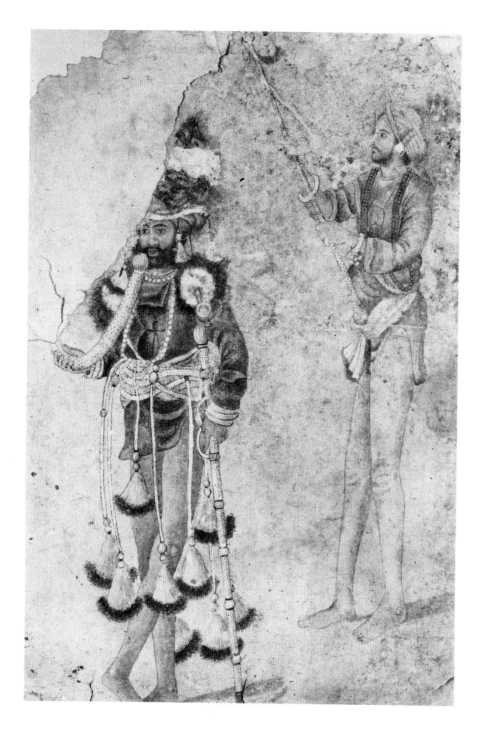

27 *A Holy Man with Attendant*
Delhi, Company style; ca. 1815
Watercolor on paper
H. 28.2 cm., W. 19.4 cm.
Lent anonymously

We have met this betasselled holy man and his attentive follower before, in *A Flower from Every Meadow* (no. 72), painted as part of a larger group. This version, however, seems more closely observed and is probably earlier. Such human *curiosa* were (and are) aspects of India that fascinate foreigners. We gaze at them a bit sheepishly and uncomprehendingly, bewildered by all the levels they represent: the superficial one of plumes and weird gadgets; the worldly one of a hand reaching for a rupee; and another that keeps alive an age of faith.

Deccani Art

28 *Inhabited Arabesque*

Deccan, Golconda (?); late 16th century
Reddish-black line on paper, with touches of white
H. 11.4 cm., w. 6.4 cm.
Lent by the Jagdish and Kamla Mittal
Museum of Indian Art

For specialists in Indian painting, the Deccan is the most fascinating and controversial area of expertise. In this area, south of Mughal Hindustan, the Sultanates of Ahmednagar, Golconda, Bijapur, and several other states preceded the Mughal empire in India. Stylistically the artistic traditions of these lesser-known Muslim courts usually revealed closer ties to Iran. Although it is dangerous to generalize, it seems safe to say that Mughal art ordinarily interprets the world in clear, sunlit prose while that of the Deccan is lunar and in verse. A Mughal portrait usually shows the sitter accurately proportioned, in sharp focus, with flaws as well as perfections. A Deccani one is less likely to be specific about colors and textures, more concerned with mood, and prone to expressive distortions of form. In terms of elephants—a favorite Deccani subject—if a Mughal elephant materialized next to us, we would be appropriately frightened and impressed, but a Deccani elephant would astound and delight. We would probably pat him and look for the other floats in the parade.

To further characterize Deccani art, we ask if it is ever awesome, as Mughal art can be. Probably not, for lacking the degree of naturalism found in Mughal art, there is less empathy. But this does not mean that Deccani art is less profound; it can be extremely mystical, elevated, and elevating.

Like other examples of Deccani art at its best, this arabesque design is a flight of fancy that carries us into an other-worldly realm. It is closely related to Iranian arabesques in its rhythmic interlace of flowering tendrils, but the Deccani artist has imbued it with extra intensity, has supercharged it, so to speak, with extravagance. While Iranian designers also enlivened their arabesques with fantastic birds, dragons, fish, and other creatures, this artist has given them a special twist and slither typical of India and particularly of the Deccan.

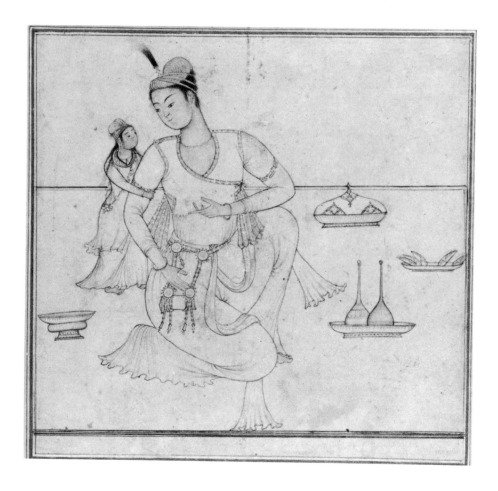

29 *A Deccani Prince with a Little Girl*

Deccan, Bijapur (?); last quarter of the 16th century
Black line and gold on paper
H. 15.4 cm., W. 16 cm.
Lent by Mr. Edwin Binney, 3rd

This dignified yet playful portrait is probably from Bijapur, although the attribution, like most early Deccani ones, would be hard to prove. Much of old Bijapur still stands, a vast out-of-door architectural museum, dominating the hurly-burly of a modern Indian town. More ethereal than Mughal architecture, its ruins seem as though they must erode up rather than down, heavenwards instead of into the soil. It is a place where the popular fictions of flying carpets, genii in bottles, and pools of precious stones would seem to belong. But it is also a place of restraint—a setting for classical fantasies, not outrageous ones.

Bijapur was founded in the late fifteenth century by Yusuf 'Adil Khan, who is said to have fled at seventeen to India on the death of his father, Sultan Murad II of Turkey. In India, he sold himself as a slave to Mahmud Gawan, the minister of the Bahmani kingdom, another pre-Mughal Muslim sultanate. Talented and energetic, Yusuf rose to a position of authority under the Bahmanids, after which he established his own kingdom at Bijapur. Religiously tolerant, he was known for justness and integrity. He invited philosophers, poets, artists, and other notables from Iran, Rum, and Turkestan, and established a distinguished court which survived until its annexation by Aurangzeb in 1686.

This drawing is almost without Mughal influence and must date from the last quarter of the sixteenth century, during the reign of Ibrahim 'Adil Shah II (r. 1579–1626). Later portraits from this period are more closely observed, in the Mughal fashion, whereas here faces, costumes, and setting are treated according to a more Iranian or Ottoman ideal. Faces are like full moons, and the line is gracefully calligraphic. The prince's opulent gold belt — almost a harness—conveys something of the abundant richness associated with Bijapur and the other Deccani sultanates.

Published: Binney, *Indian Miniature Painting from the Collection of Edwin Binney, 3rd*, no. 120.

30　*A Prince Holding a Flower*
　　Deccan, Bijapur (?); ca. 1585
　　Black line with gold and color on paper
　　H. 12 cm., W. 7.4 cm.
　　Lent by the Jagdish and Kamla Mittal
　　Museum of Indian Art

Luxuriously draped in a long scarf and adorned with neck-laces, the young prince admires a fragrant bloom. Carrying his book (of poetry?), he would seem a suitable companion to Ibrahim 'Adil Shah II, the poet-musician-ruler who managed to juggle these diverse, usually incompatible talents during a long, successful reign in Bijapur. Conceivably this is a likeness of the ruler himself. Inscribed later portraits show him to have been heavy set, with a large aquiline nose like the one apparent in this youthful portrait.

Although the sitter seems to have been rather solidly proportioned, he has not been described with bold, substantial forms, such as we find in Basawan's early Mughal portraits (Nos. 7, 9). Instead, the artist's touch is feathery and gentle and the flat, white face makes us think of a Japanese theatrical mask.

For a reliable later likeness of Ibrahim 'Adil Shah II, see: Hermann Goetz, *The Art and Architecture of Bikaner State* (Oxford, 1950), pl. 8. See also: Robert Skelton, "Documents for the Study of Painting at Bijapur," *Arts Asiatiques* 5 (1958), fasc. 2, pp. 97–125.

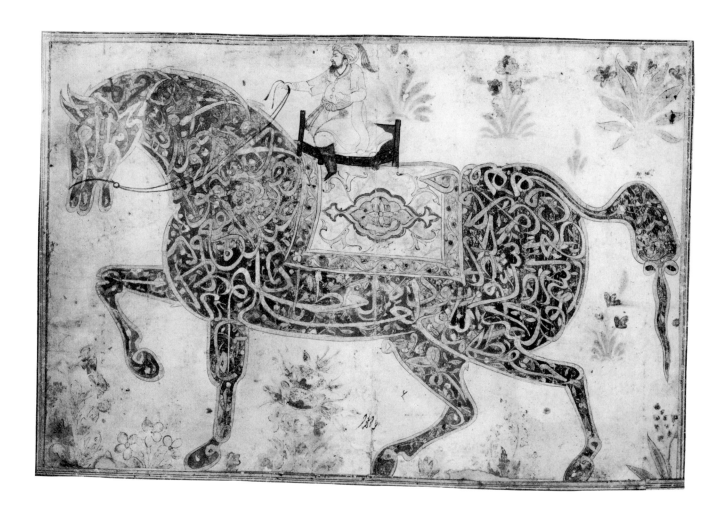

31 *Horse and Rider*

Deccan, Bijapur (?); late 16th century
Black line with gold and color on paper
H. 16.7 cm., w. 25.5 cm.
Lent anonymously

In this calligraphic picture, *naskhi* script is arranged in the form of a horse ridden by an incongruously small, bearded man, drawn with calligraphic flourishes. The rider sits on a throne-like saddle, presumably a reference to the so-called "Throne Verse" from the section of the *Qur'an* known as "The Cow" (verse 254). In this ornamental form, this visual allusion to the verse is intended for use as a talisman. This is the earliest pictorial calligraphy we have seen from the Deccan. The decorative flowers in the background link it to many of the miniatures in a manuscript of the *Nujum al-Ulum* ("Stars of the Sciences") in the library of Sir A. Chester Beatty, which is dated in three places to 1570 and was once in the library of Ibrahim 'Adil Shah II (see No. 30). Although this picture is probably later, it appears to stem from the same artistic milieu. Unfortunately, the inscriptions have been obliterated.

For the *Nujum al-Ulum,* see: Thomas W. Arnold, *The Library of A. Chester Beatty: A Catalogue of Indian Miniatures,* rev. and ed. J. V. S. Wilkinson (Oxford, 1936), vol. 2, pls. 3–5; and Douglas Barrett, *Painting of the Deccan, XVI–XVII Century* (London, 1958), pl. 2. For calligraphy in general, see: Annemarie Schimmel, *Islamic Calligraphy* (Leiden, 1970).

Published: S. C. Welch, "Portfolio," *Marg* 16, no. 2 (1963), p. 31.

32 *A Prince with a Hawk*

Deccan, Bijapur (?); early 17th century
Black line with gold, white, and slight color on paper
H. 16.5 cm., W. 8.5 cm.
Lent by the Jagdish and Kamla Mittal
Museum of Indian Art

An especially elegant prince, holding a flapping hawk in one hand with the bird's jesses around his wrist, stands in a distanced landscape. Were it not for such details as the particularly windswept ties and tails of the prince's *jama* or the style of his dagger and turban, this drawing might be mistaken for a Mughal work, since both landscape and composition conform to the Mughal manner. By 1600, the Mughal and Deccani schools had influenced one another. Deccani artists had joined Akbar's growing ateliers, where their original styles had been absorbed, and the prestigious imperial manner had been felt at the Deccani courts. Portraits and other miniatures must have been exchanged as royal presents and admiringly studied by the recipients' artists. Moreover, artists often accompanied embassies, to report on what they saw, and they would have exchanged ideas with their Deccani or Mughal colleagues.

There are at least three other versions of this picture, one in the collection of Jagdish Goenka of Calcutta, another in the Gulistan Library, and a third in the library of Sir A. Chester Beatty. All of them appear to be later than the Mittal picture, which is far less stiff, more carefully observed, and more convincing as a portrait. The others, in fact, reduce this individualized characterization to a stock type. Both the Gulistan and the Beatty pictures are inscribed with the artist's name—Farrukh Beg, a Mughal artist originally from Khorasan. According to Robert Skelton, Farrukh Beg visited the Deccan and painted there.[1] If so, he must have studied and copied the Mittal drawing, or another version of it. Inasmuch as the Mittal portrait lacks Farrukh Beg's almost glacial hardness of outline and is far less static in the treatment of the prince, his hawk, and the landscape, it cannot be claimed as his work.

For the Beatty version, see: Arnold, *Beatty Indian Miniatures,* vol. 3, pl. 64. The Gulistan Library portrait was published by Yedda Godard, "Un album de portraits des Princes Timurides de l'Inde," *Athar-e Iran* 2, fasc. 2 (1937), fig. 95. The Goenka version, which is almost identical to the Gulistan picture in composition and color, has not been published.

1. Robert Skelton, "The Mughal Artist Farrokh Beg," *Ars Orientalis* 2 (1957), pp. 393–411 and figs. 8, 11.

33　*Fighting Elephants*
　　By Farrukh Husayn
　　Deccan, Bijapur; early 17th century
　　Black line with gold and color on paper
　　H. 18.9 cm., w. 26.3 cm. (without border)
　　Lent by Mr. Edwin Binney, 3rd

This quietly ferocious encounter is so close to the work of Farrukh Husayn, an early seventeenth-century Bijapur artist, that it can be ascribed safely. Like his other pictures, this one is a drawing in black line, with bright accents of color. An artist who specialized in elephants, he invariably set the animals against an ornamental "jungle" of gold trees and flowers. Although one of the mahouts here looks distinctly upset as the opposing elephant's trunk curls round his neck, the atmosphere of the picture is buoyantly jolly.

　　Another important Deccani version of the subject is a stucco relief of fighting elephants which survives over a door in the late sixteenth-century pavilion at Kumatgi.

For the painter Farrukh Husayn, see: Nazir Ahmed, "Farrukh Husain, the Royal Artist at the Court of Ibrahim 'Adil Shah II," *Islamic Culture* 35, no. 2 (April, 1956).

Published: Binney, *Indian Miniature Painting from the Collection of Edwin Binney, 3rd,* no. 124.

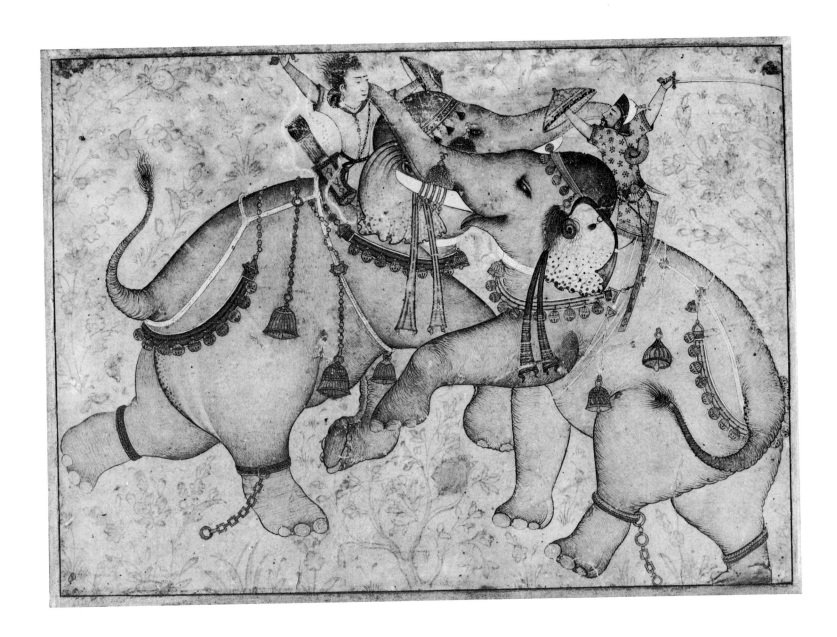

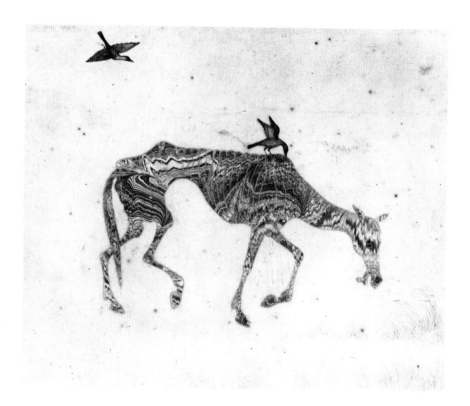

34 *A Starving Horse, Harassed by Birds*

Deccan, Bijapur; ca. 1625
Marbleizing, gold line, and touches of color on paper
H. 13.4 cm., W. 16.7 cm.
Lent anonymously

Emaciated horses frequently appear in Islamic art, although the motif probably was inspired by Chinese prototypes.[1] One could assemble a miserable cavalry regiment of Safavid ones as well as Indian nags from the Mughal and Deccani courts. Their meaning can be interpreted variously. Perhaps it was, and is, consoling to see a creature whose misery and pain dwarf one's own, especially when the tragic old thing still pushes hopefully ahead, where there is always a bit more grass. Perhaps, too, this picture could inspire a meditation upon the transmutation of pain into beauty, or upon one of nature's cruel paradoxes, the innocent birds torturing the starving horse.

Annemarie Schimmel has written an article on this theme as expressed in Sufi art and poetry.[2] She tells us that starving horses symbolize the transitory world and are associated particularly with the decay of the body. When they are shown with riders, the latter represent the soul, as opposed to the body which must be controlled by it.

Marbleizing was a Bijapuri specialty, often employed in the margins of calligraphies and miniatures as well as to create complete pictures, as here. For a design as complex as this one, the artist covered with a resistant gum the area of the paper to be left unadorned. Next he floated and swirled pigments in oil on the surface of a vat of water. The paper was then either raised or lowered to contact the pigment. The artist of this picture was a great virtuoso who was able to give his horse a backbone, joints, and an eye socket by controlling the floating colors. After the marbleizing, he drew outlines, ribs, and eyes in gold and black. The grass and birds were then painted, to complete his dramatically disturbing picture.

Two other pictures of starving horses, one showing an equally ascetic rider and the other lacking both birds and rider, can be attributed to the same artist (The Metropolitan Museum of Art, accession no. 44.154, and the Museum of Fine Arts, Boston, accession no. 14.695).

1. See: Stuart Cary Welch, "Early Mughal Miniature Paintings from Two Private Collections," *Ars Orientalis* 3 (1959), no. 13, fig. 16.

2. Annemarie Schimmel, "Nur ein störisches Pferd," *Festschrift George Widengren* (Leiden, 1972), pp. 98–107.

35 A Begum

Deccan, Bijapur; ca. 1625
Marbleizing, ink, gold, silver, and touches of
color on paper
H. 23.2 cm., W. 13.5 cm.
Inscribed: "Khor Khanum" ("Sun Lady");
"Favari" (perhaps a family name)
Lent by the Jagdish and Kamla Mittal
Museum of Indian Art

She is a Deccani *grande dame* with a fat, motherly face, decked
out with nose ring, fringe, plumes, prayer beads, necklaces,
and flying scarves. Her features are drawn in bold, quick
strokes, sharp-nosed and sharper-eyed, slightly askew under
dense black hair. Seated in a bulbous heap, she holds a sprig
of flowers in one plump hand. She looks warmhearted and
extremely opinionated—a loyal friend, but a tigress of an
enemy.

The obese begum is probably from the same atelier as the
starving nag, one whose artists showed a penchant for ex-
tremes. Both figures are developed from areas of marbleiz-
ing, heightened with gold and a few effective strokes of
black and color. Both, too, raise their subjects to memorable
symbols.

We note elsewhere (No. 42) that gentlewomen were not
ordinarily shown in full view, an overly familiar pose re-
served for courtesans and Europeans. This lady may be an
exception because of either her seniority or her invulnerable
personality, which would have made short work of anyone
with wrong intentions.

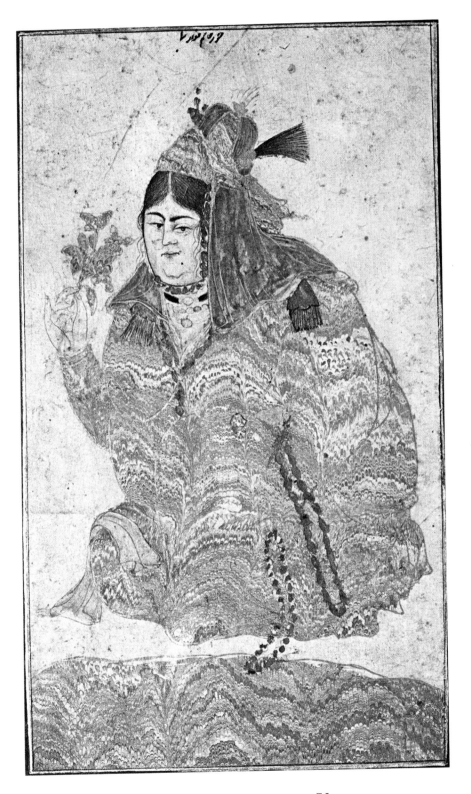

36 *Burhan al Mulk's Elephant*
Deccan, Ahmednagar; ca. 1590–95
Black line with gold and color on paper
H. 19.5 cm., W. 16.8 cm.
Lent anonymously

This smiling elephant, tinkling with bells, is by the same artist as a well-known portrait of the Ahmednagar ruler, Burhan al Mulk.[1] His markedly personal style is notable for its strong wiry line, alternating with an unmistakable wiggly one, as here at the edge of the saddle blanket.

Burhan's career was colorful, if troubled. In a plot to seize the throne, a discontented faction at the Ahmednagar court of his brother Murtaza Nizam Shah I spirited him into the capital disguised as a holy man. The plot failed, and Burhan fled to Konkan, Bidar, and eventually Lahore, where he was received by Akbar at court on March 21, 1585. A painting of about this date made for Akbar shows a Deccani nobleman and was probably based on this visit.[2] The Mughal emperor saw Burhan as a means of extending his empire into the Deccan. He gave the prince support to take over Ahmednagar and, although the first attempt failed, with the further assistance of Raja 'Ali Khan and Ibrahim 'Adil Shah II of Bijapur, the second succeeded. Burhan ascended the throne in 1591. An enthusiast of wine, women, and song (as well as painting), he enjoyed a reign of four years before he died in 1595.

For a history of this state, see: Radhey Shyam, *The Kingdom of Ahmadnagar* (New Delhi, 1966).

Published: Welch, "Portfolio," p. 11.

1. This majestic portrait of the portly ruler was first identified by Douglas Barrett, *Painting of the Deccan,* pl. 5. Another unpublished portrait is in the Rampur State Library.
2. Folio 74 recto of the *Darab-nama* in the British Museum (OR.4615). This miniature is inscribed with its artist's name, Madhu the Younger.

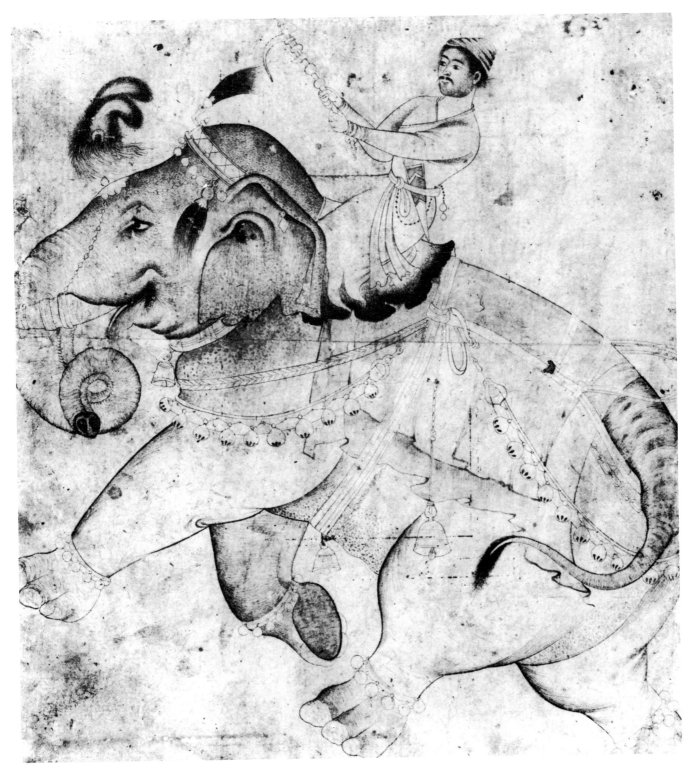

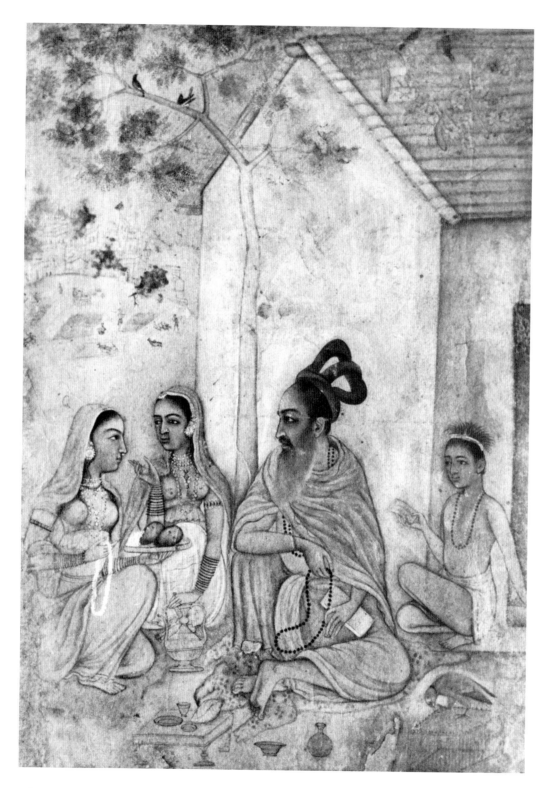

37 *Two Elegant Ladies Visit a Sadhu*
Deccan, Aurangabad; ca. 1650–60
Black line and color on paper
H. 17.6 cm., W. 12.7 cm.
Lent by the Jagdish and Kamla Mittal
Museum of Indian Art

Two richly dressed, beautiful women make offerings to an equally elegant holy man, whose long hair is knotted into a "crown." He sits beneath a tree on a leopard skin, in front of a small table or altar that holds a conch shell and vessels. A parrot scratches his beak on the top of his cage near the *sadhu*'s charming boy apprentice (*chela*). Presumably the ladies have come requesting a boon—aid in a love affair, or in conceiving an heir. The artist has carefully modulated the tones of the whitewashed stucco hut behind the figures and lavished much attention on the agricultural scene and city in the distance.

The city is probably Aurangabad, the center of Mughal power in the Deccan after 1635. Many pictures can be associated with Aurangabad, where members of the imperial family, Mughal nobles, and Rajput princes (particularly from Bundi, Kotah, and Bikaner) provided patronage. Their skillful artists worked in styles ranging from almost purely Mughal idiom, as here, to strongly Rajput, but usually with enough local elements to prove their place of origin. This picture is related to many of the miniatures and drawings used to "paper" the walls of the so-called *Millionenzimmer* in Maria Theresa's palace at Schönbrunn near Vienna—although it is far more sensitively and finely painted than most of them. (See: Josef Strzygowski, *Die Indischen Miniaturen im Schlosse Schönbrunn* [Vienna, 1923].)

Saryu Doshi has published miniatures from Aurangabad in a more Rajput style: "An Illustrated Manuscript from Aurangabad, Dated 1650 A.D.," *Lalit Kala* 15 (n.d.), pp. 19–28. On the basis of her article, "Lalita Ragini" in Stuart Cary Welch and Milo Cleveland Beach, *Gods, Thrones, and Peacocks* (New York: The Asia Society, 1965), no. 18, should be reassigned to Aurangabad or at least seen as the work of an artist from there.

38 *A Mihrab in Kufic Script*
Deccan, Hyderabad (?); ca. 1800
Black line on paper
H. 20.6 cm., W. 13.6 cm.
Lent anonymously (*illustrated p. 17*)

This representation of a *mihrab* (a prayer niche, facing the worshipper in a mosque or shrine and also facing toward the holy city of Mecca) is archaistically composed in Kufic, the early Muslim script that is perhaps the noblest ever conceived for the words of God. It reads: "In the name of God the Merciful, the Compassionate. Almost would the infidels strike thee down with their looks when they hear the warning of the *Qur'an*. And they say, 'He is certainly possessed.' Yet it is nothing less than a warning for all creatures" (*Qur'an*, 68:51–52).

As the quotation from the Muslim holy book suggests, this brilliant geometric design is a talisman against the evil eye. It was probably written (or drawn) at Hyderabad, a major center of Mughal power in the Deccan after the death of Aurangzeb in 1707. The province (*subah*) of the Deccan became independent of the ever-weakening Mughal empire in 1724 during the reign of Muhammad Shah when its governor, the Nizam-ul-Mulk Asaf Jah, a leading Mughal nobleman, moved from Delhi to the Deccan and declared himself independent. The descendants of Asaf Jah, known as the Nizams of Hyderabad, ruled their huge state until the transfer of power to the Republic of India in 1948. Hyderabad is still a major center of Islamic culture.

Rajput Art: Rajasthan

39 *Rana Amar Singh II*

Rajasthan, Mewar; ca. 1698
Black line with gold, color, and touches of white
on paper
H. 51.3 cm., w. 39 cm. (sight)
Inscribed: "Maharaja Sri Raj Sri Amar Singhji
doing *japa* at important worship."
Lent anonymously

Colonel James Tod, the early nineteenth-century British civil servant whose *Annals and Antiquities of Rajasthan* is probably the most informative book ever written about the Rajputs, tells us that Amar Singh II (r. 1698–1710) was "an active and high-minded prince, who well upheld his station and the prosperity of his country" (*Annals and Antiquities of Rajasthan*, vol. 1, p. 471). As the premier nobleman of Rajputana, he could trace his family back to the sun; and his ancestors were the last to hold out against the Mughals, who were extremely eager to gain their service. Threats, intrigue, and military power all failed to conquer the proud Ranas. During the reign of Jahangir, however, Rana Amar Singh I reluctantly agreed to send his son and heir, Karan, to the imperial court, where he was most generously and honorably received. In spite of Jahangir's many favors (which included placing large statues of the Rana and his son in the imperial gardens, the privilege of not coming to court, and quantities of rich presents), Rana Amar

Singh felt humiliated by his relationship to the Mughals. He turned over the honor of Mewar to his son, made the *tika* (a caste mark) on his forehead, and permanently withdrew from the capital to Nauchauki, about half a mile beyond the city walls of Udaipur.

In this drawing the gentle descendant and namesake of the first Rana Amar Singh is shown at prayer. He wears a dhoti and is seated cross-legged, in the lotus position. With his right hand he rotates prayer beads beneath a *gomukhi*, a cloth bag used in Vaishnavite worship. Among his many jewels is a gold pectoral, set with precious stones in the form of peacocks, the bird sacred to Krishna. This portrait shows him at a young age, probably soon after his accession in 1698. Drawn in a sure, wiry outline, with each hair of his moustache and head separately delineated, this likeness appears to be by the same hand as the portrait of his wife's monkey exhibited at Asia House Gallery in 1965 (see: Welch and Beach, *Gods, Thrones, and Peacocks,* no. 26).

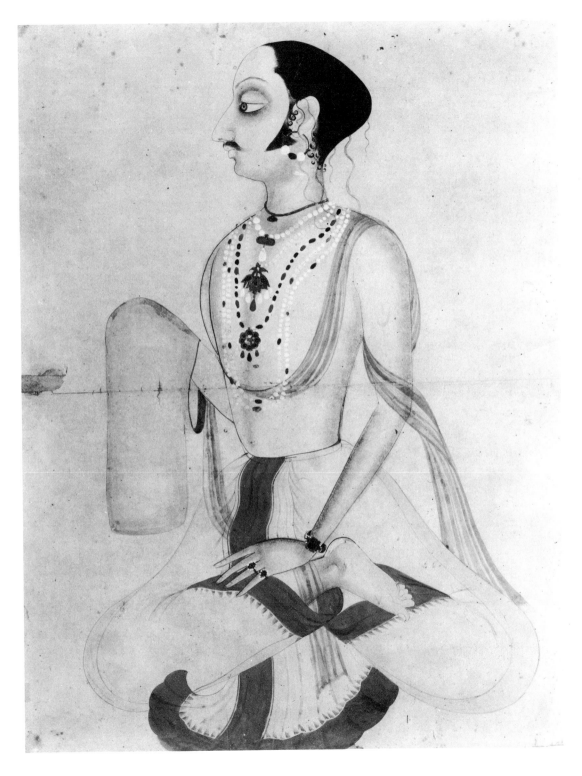

40 *Procession of Rao Ratan*

Rajasthan, Bundi, ca. 1625
Black line with color washes on paper
H. 24.2 cm., W. 68.5 cm.
Inscribed: "Raoji Rat . . . ji" (the obliterated
letters must be "an")
Lent by the Jagdish and Kamla Mittal
Museum of Indian Art

The case of Rao Ratan of Bundi (r. 1607–31) sheds insight
into Mughal–Rajput politics. When Ratan remained loyal to
Emperor Jahangir at the time of Prince Khurram's revolt,
he was made governor of Burhanpur, the seat of Mughal
power in the Deccan, and given the most august Mughal title
in the area, Sarbuland Rai. Simultaneously, however, the
emperor presented Kotah to Ratan's son, Madhu Singh, and
thereby effectively split in two the Hara family and power.
After Shah Jahan (the erstwhile Prince Khurram) came to
the throne in 1627, he confirmed the Kotah grant and when
Rao Ratan came to pay homage at court, the emperor
showed that he bore no grudge by giving him a robe of
honor, a decorated dagger, a flag, a drum, a horse with a
golden saddle, and an elephant. He also confirmed him in
his right to command five thousand foot soldiers and five
thousand horsemen, a high position in the imperial hier-

archy. In 1631, Rao Ratan was killed in action near Bur-
hanpur.

In style, this drawing is more Mughal than Rajput, falling
into the category known as "popular" or sub-imperial
Mughal in its simplifications of form, while adhering to the
Mughal interpretation of space. It might well have been
done by one of the artists released by Jahangir from the
court workshops at the time of his accession. These artists
found ready employment at such courts as Bundi as well as
in bazaar workshops, where commercially inspired manu-
scripts of Muslim and Hindu subjects were turned out in
quantity. In all likelihood, there were also Mughal artists
at Burhanpur at the time Rao Ratan was governor there.
One of them may have drawn this lively description of a
Rajput procession.

See: Tod, *The Annals and Antiquities of Rajasthan,* vol. 3, pp. 1486–87.

41 *Kamod Ragini*

Rajasthan, Bundi; ca. 1625
Black line and slight color on paper
H. 20.7 cm., W. 11.2 cm. (without border)
Lent by the National Museum, New Delhi

Kamod ragini is one of the less frequently illustrated themes
in the series of thirty-six pictures forming a *ragamala* set,
one of the most common pictorial subjects in Rajput art.
Each picture is known either as a *raga* (masculine) or *ragini*
(feminine) and is appropriate to a special time of day, sea-
son, mood, place, and musical theme. Artists and musicians
were free to interpret these traditional modes, which, there-
fore, were never twice painted, played, or sung in precisely
the same way.

This drawing was made for an artist's (or atelier's) own
use, to serve as a guide for other versions of the subject.
Many such drawings have survived, often with color nota-
tions, as here, but few are as early as this or as intricately
worked. Unusually moving is the attenuated characteriza-
tion of the wasp-waisted heroine, Kamod, who has fled dis-
tractedly into the jungle because of the absence of her lover.
In fear and despair, she looks about her; she trembles at the
cry of a cuckoo.

The author is grateful to Milo C. Beach for telling him of
a similar but later drawing of the same theme in the same
collection, as well as for pointing out a painted version in
the collection of Gopi Krishna Kanoria of Patna. The latter
may well have been based on this very drawing.

42 The Vamp

Rajasthan, Bundi or Kotah; ca. 1700
Black line and color on paper
H. 32 cm., W. 19.2 cm.
Lent by the National Museum, New Delhi

This sultry, sloe-eyed beauty must have been particularly admired by the Maharaja who commissioned her portrait. She gazes at us flirtatiously, self-assured and proud of her European hat, which seems to be a curious hybrid, somewhere between a beret and a lotus leaf. Mughals and Rajputs alike enjoyed the furbelows of Europeans, which were portrayed by Mughal artists as early as the Akbar period (1556–1605). One wonders if the unusually large scale of this drawing might not also reflect European influence. Two other versions of this picture are known to the author, but this one is the most spontaneous and lively.

In comparison to Mughal equivalents, this portrait is far less formal and more expressive. Usually Mughal or Mughal-inspired portraits of women show them in profile, probably because a frontal view implied all-too-audacious friendliness on the part of the sitter. In Rajput art, too, it seems that "ladies," as opposed to "women," did not face anyone other than their husbands or other members of their families (see also Nos. 35, 57). The fact that our vamp is shown full-face suggests that she was of lowly morals (i.e., a dancing girl or courtesan) or simply playing at being a European, which no "decent" person would have done.

For a highly informative *omnium gatherum* on the subject of Indian courtesans, see: Moti Chandra, *The World of Courtesans* (New Delhi, 1972).

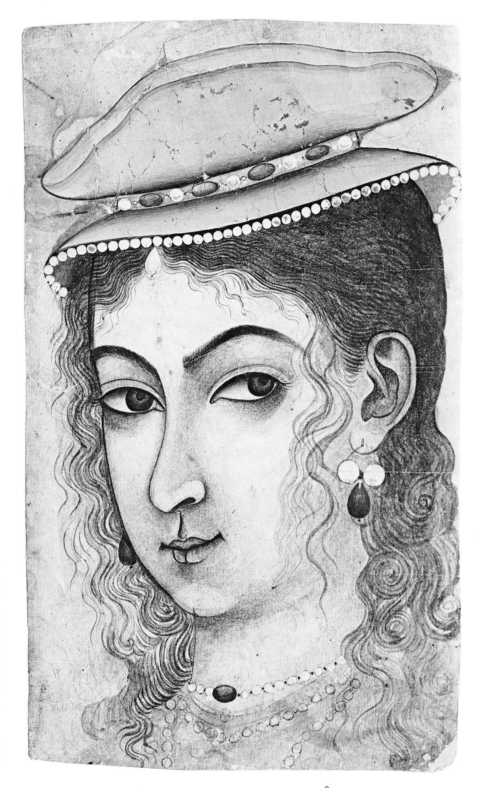

43 *Krishna Spies on the Gopis*
 Rajasthan, Bundi; ca. 1775
 Black and reddish-brown line on paper
 H. 29.2 cm., W. 20.5 cm.
 Lent by Mr. Ralph Benkaim

The Ras Lila, a dance in which the god Krishna sports at
Brindaban with the cowgirls, or *gopis*, is a particularly pop-
ular theme in Rajasthan painting. In this Bundi drawing,
Krishna is seen before the dance spying on the girls, who
are arranged in a circle looking ahead to the dance itself.
They are feasting in the shade of a large tree, while birds and
monkeys cavort in its boughs and around the platform—
allusions, perhaps, to the ancient Indian belief in trees as
fertility symbols. The girls twitter, gossip, and strike delight-
ful dance-like poses. One seems to have spotted Krishna,
who is not very effectively hidden behind palm fronds; she
coyly fastens her eyes on him. Perhaps she is Radha, Krish-
na's beloved. The god is dressed as a Bundi prince, and the
girls are probably based on actual beauties at court, where
playing "Krishna and the *gopis*" must have been a popular
game!

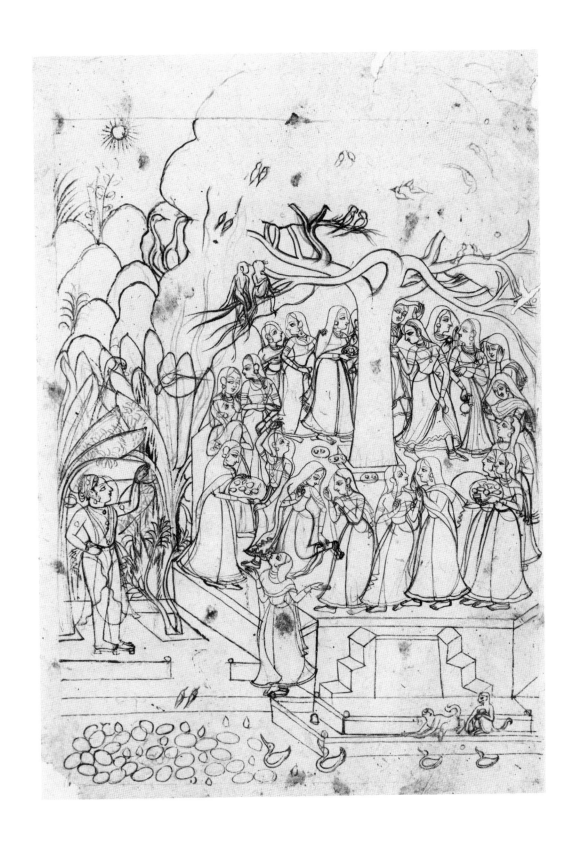

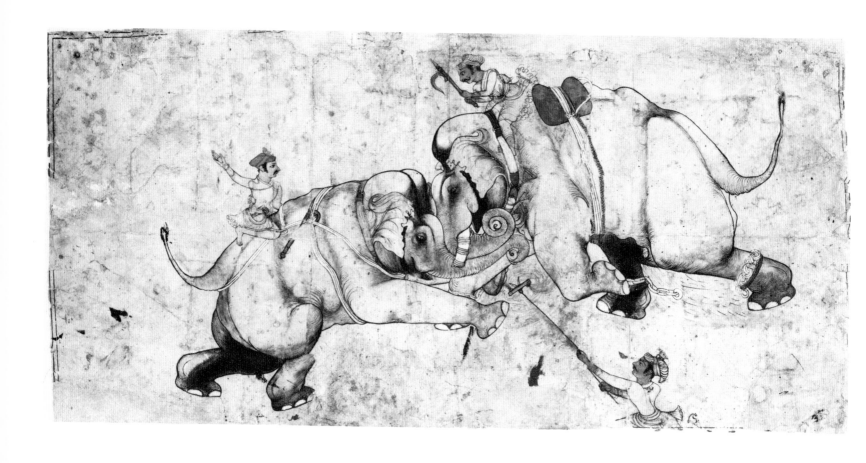

88

44 An Elephant Combat

Rajasthan, Kotah; late 17th century
Black line with slight color and touches of white
on paper
H. 34.3 cm., w. 67.4 cm.
Lent anonymously

The French traveler François Bernier, who was in India from 1656 to 1668, described an elephant combat: "A wall of earth is raised three or four feet wide and five or six high. The two ponderous beasts meet one another face to face, on opposite sides of the wall, each having a couple of riders, that the place of the man who sits on the shoulders, for the purpose of guiding the elephant with a large iron hook, may be immediately supplied if he should be thrown down. The riders animate the elephants either by soothing words, or by chiding them as cowards, and urge them on with their heels, until the poor creatures approach the wall and are brought to the attack. The shock is tremendous, and it appears surprising that they ever survive the dreadful wounds and blows inflicted with their teeth, their heads, and their trunks. There are frequent pauses during the fight; it is suspended and renewed; and the mud wall being at length thrown down, the stronger or more courageous elephant passes on and attacks his opponent and, putting him to flight, pursues and fastens on him with such obstinacy that the animals can be separated only by means of *cherkys*, or fireworks, which are made to explode between them; for they are naturally timid and have a particular dread of fire, which is the reason why elephants have been used with so little advantage in armies since the use of firearms."[1]

No artists understood how elephants move better than the Indians, and of the Indian artists, those of Kotah were unequalled. One might further add that the unnamed draftsman of this picture was the wizard among wizards of the Kotah school. Uncanny as an observer, he seems to have felt each muscle, flickering wrinkle, or buckling outline, and recorded the elephants with dragonish fire, so that they resemble earthquakes in slow motion. As *the* Kotah master, he probably should be credited with the penchant for line evident in the art of Kotah, throughout its history the most drawing-conscious school in Rajasthan.

Calligraphic as well as dynamic and convincingly descriptive, Kotah linearism seems closest to that of fifteenth-century Tabriz, where the Turkmans employed the only other artists we know who drew with the same combination of elements. Moreover, the Kotah artists perpetuated several of the Turkman motifs, such as the dragons of No. 50. It seems likely, therefore, that the Kotah artists were directly descended from the Turkman ateliers and retained tracings and other *materia technica* stemming from fifteenth-century Iran. We further suppose that the Kotah artists had been brought from the Deccan, where one also finds these motifs, though in a less electrifying form. Apparently the Kotah patrons were closer aesthetically to the fifteenth-century Turkman princes than were the seventeenth-century Deccani patrons for whom these artists had previously painted.[2]

Our elephant combat must have been drawn for Ram Singh I (r. 1686–1707), whose portrait by the same artist showing him riding another majestic elephant in pursuit of a rhinoceros was included in the first Asia House exhibition of Rajput painting (see: Sherman Lee, *Rajput Painting* [New York, 1960], no. 36).

For another elephant combat, dated 1725 and signed "Niju," that appears to be copied from one by our artist, see: Milo C. Beach, *Rajput Painting at Bundi and Kota* (Ascona, 1974), fig. 126.

Published: Ashton, ed., *The Arts of India and Pakistan,* no. 484.

1. François Bernier, *Travels in the Mogul Empire, A.D. 1656–68*, ed. Archibald Constable (London, 1891), pp. 278–79.
2. As high-ranking Mughal officers, the Kotah princes were in the Deccan for long stretches of their lives. The first of them, Rao Madhu Singh (r. 1625–30) was at Burhanpur with his father, Ratan Singh of Bundi (see No. 40). He was awarded Kotah as a grant by Jahangir for his loyalty at the time of Prince Khurram's revolt. Mukund Singh (r. 1630–57) was one of five brothers who fought on behalf of Dara Shikoh and Shah Jahan against Aurangzeb. Only one of them survived, Kishor Singh, a leader of the imperial forces at the capture of Bijapur. Rao Jagat (r. 1657–70), son of Mukund (the first Kotah ruler of whom there are surviving Kotah portraits), was in the Deccan during most of his reign. The above-mentioned Kishor Singh became the next Rao. He was slain at Arcot in 1686, when he was succeeded by Rao Ram Singh I, who embraced the cause of Prince Azam (see No. 22), son of Aurangzeb and viceroy of the Deccan. Rao Ram Singh was slain at the battle of Jajowan in 1707, fighting against Prince Mu'Azzam who became Emperor Bahadur Shah (r. 1707–12).

45 *The Glory of War*
Rajasthan, Kotah; late 17th century
Black line and slight color on paper
H. 45.5 cm., W. 56.9 cm.
Lent anonymously

Torn, battered, and fragmented, this drawing remains a vivid account of Rajput heroism and military technology. Almost encyclopedic in its detailed rendering of arms and armor, it must have thrilled generations of Rajputs, who could read it through eyes trained to see glory in battle. As the two armies meet, elephant bells clang and kettledrums pound over the war cries. Two major episodes develop: in the left foreground, a hero is torn from his horse and crushed by an elephant, into whose trunk he drives a *katar* (dagger); meanwhile, at the upper left, there is a skirmish round a bloodied body, presumably slain in an earlier en-counter. Hard-pressed by the enemy, the warrior's follow-ers try to drag his corpse from the field.

Each of the hundreds of men, elephants, and camels is drawn with portrait-like individuality, down to the last bit of chain mail, *tulwar* (saber), or plume. Perhaps by the same artist as the "Elephant Combat" (No. 44), this drawing shows brushwork that is more dashingly sketchy. Most in-telligently, the composition is "pinned" together by an ef-fective repetition of the circular shields and the diagonal lines of the spears.

Published: Beach, *Rajput Painting at Bundi and Kota,* figs. 78, 79.

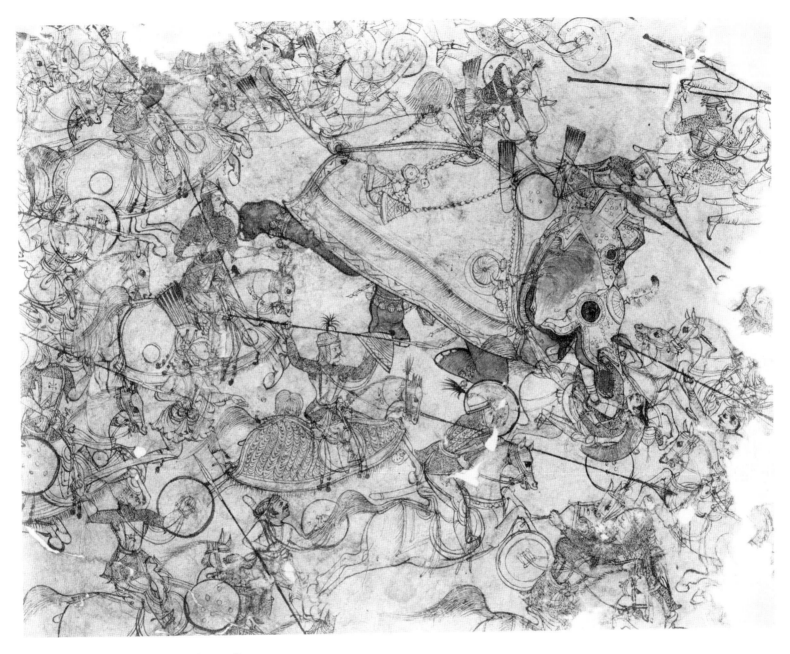

Detail, No. 45 (entire drawing not illustrated)

46 *A Feast*

Rajasthan, Kotah; ca. 1705
Black line on paper
H. 19.8 cm., W. 13 cm.
Lent anonymously

Kotah artists wandered freely, sketching all aspects of life. When he drew this, the artist was surrounded by the lowly diversions of Rajput soldiers, whose actions he jotted down as they ate, drank, roughhoused, passed out, and vomited. His brush was fast as lightning, and we are reminded of Rembrandt's equally penetrating and dashing sketches.

At least one of the figures was later put to use—the seated figure smoking a water pipe in the middle foreground. His outline has been pricked to transfer to another picture.

Published: Beach, *Rajput Painting at Bundi and Kota,* fig. 77.

47 *War Chariot*

Rajasthan, Kotah; ca. 1725–30
Black line on paper
H. 16.2 cm., W. 21.8 cm.
Lent anonymously

The windblown pennants, flying gallop of the horses, and absence of a ground line lend this battle a fantastic airiness, belied by the trampled corpses and the arrows bristling in the charioteer—signs of fierce warfare. Riding ahead of the chariot is a Kotah ruler, probably Maharao Durjan Sal (r. 1723–56), here shown early in his reign. According to James Tod, "He was a valiant prince, and possessed all the qualities of which the Rajput is enamoured; affability, generosity, and bravery. He was devoted to field-sports, especially the royal one of tiger-hunting; and he had *ramnas*, or preserves, in every corner of his dominions (some of immense extent, with ditches and palisadoes, and sometimes

circumvallations), in all of which he erected hunting-seats"
(*Annals and Antiquities of Rajasthan,* vol. 3, p. 1530).

Drawings and paintings from his reign suggest that Rao
Durjan was a major art patron, especially fond of hunting
and battle scenes. The drawing at hand, particularly in the
portrait, has a somewhat Mughal flavor, which may be at-
tributed to the Rao's interest in this style as a result of his
visit to Muhammad Shah's court. There he was officially
received and given the boon "of preventing the slaughter
of kine," sacred to the Hindus, "in every part of the Jumna
River frequented by his nation" (ibid., p. 1529).

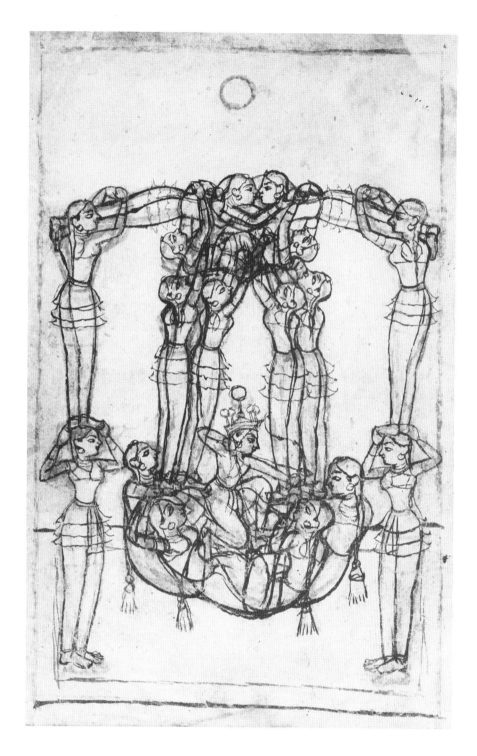

48 *A Swing of Girls*

Rajasthan, Kotah; ca. 1730
Black line and slight color on paper
H. 21 cm., W. 14 cm.
Lent by the Jagdish and Kamla Mittal
Museum of Indian Art

Luminous and with an unusually charming cast of players, this drawing describes a peculiarly Indian activity. The seventeenth-century French traveler Tavernier describes such acrobatic choreography as executed by "public women" of Golconda in the Deccan: "These women have so much suppleness that when the king who reigns at present [Abdulla Qutb Shah, 1611–72] wished to visit Masulipatam, nine of them very cleverly represented the form of an elephant, four making the four feet, four others the body, and one the trunk, and the king, mounted above on a kind of throne, in that way made his entry into the town."[1]

This precisely planned drawing may have served as a guide to the seventeen Kotah *artistes* who enacted it for Rao Durjan and his guests. The full moon implies that the performance was given at night, and the theme of Krishna on a swing brings to mind a *ragamala* subject, *Hindola ragini.* In this case it is combined with *Vibhasa*, in which the lover sometimes shoots a lotus-tipped arrow at his beloved, supposedly to rearouse her passion. Another drawing by the same hand presents a group of girls arranged as a camel. Perhaps the artist was the choreographer for such entertainments.

See: Herbert J. Stooke and Karl Khandalavala, *The Laud Ragamala Miniatures* (Oxford, 1953), pls. IV, X.

1. J. B. Tavernier, *Travels in India,* ed. W. Crooke (Oxford, 1925), vol. 1, p. 128.

49 *A Day at Gagraun Fort*
Rajasthan, Kotah; ca. 1735
Black and reddish-brown line with color washes
on paper
H. 55 cm., W. 73.1 cm.
Lent anonymously

Gagraun fort, just north of Jhalawar, defended the southern
border of Kotah, particularly crucial in the struggles against
the Marathas. James Tod in *The Annals and Antiquities of
Rajasthan* refers to it as "the celebrated castle of Gagraun,
now the strongest in Haraouti" (vol. 3, p. 1524) and later
tells us that Zalim Singh, Kotah's dynamic regent in the
late eighteenth and early nineteenth centuries, "strengthened

[Gagraun] with the utmost care, making [it] the depot of his treasures and his arsenal" (ibid., p. 1549).

Dr. Beni Gupta tells us of the fort's use by Maharao Durjan Sal, during whose reign this drawing was made. "The Maratha raids alarmed the rulers of Rajasthan. . . . By the efforts of Sawai Jai Singh a conference was called at Hurda near Ajmer which was attended by nearly all the rulers of Rajasthan in June 1734. Prominent among those who attended [was] . . . Maharao Durjan Sal of Kota. . . . This incident had bad consequences for Kota. So far the Maharao of Kota was thought to be on good terms with the Marathas, but his presence at the Hurda conference . . . proved his hostility. . . . Hence Baji Rao [the Maratha leader] . . . marched straight to Kota to punish its ruler for his open complicity and hostility. . . . Kota was attacked and bombarded for forty days. Unable to face the heavy odds, the Maharao fled to the fort of Gagron and started negotiations. Baji Rao was pacified only when the Maharao agreed to pay a fine of ten lakhs. . . ."[1]

Perhaps the large drawing of which this is the central fragment was made at this time. In it, we see the Maharao watching an elephant combat from a window overlooking the courtyard. Another elephant's tail and hind leg can be seen disappearing through the main gate. Combining the usefulness of a map with the charm of a description of life inside the fort, the picture must be turned in order to face each part correctly. The artist, one of Durjan Sal's best, has created a memorable record of the bastion, convincing us of its might and yet conveying the effect of a sunny day. Clearly the Maharao had found himself a safe and happy place of retreat.

Another section of this once very large picture is in the Jagdish and Kamla Mittal Museum of Indian Art, Hyderabad.

1. Beni Gupta, "Marathas in the States of Kota and Bundi," *Journal of the Rajasthan Institute of Historical Research* 10, no. 3 (1973), p. 4 ff. The author is grateful to Milo C. Beach for this and the other references to Gagraun Fort.

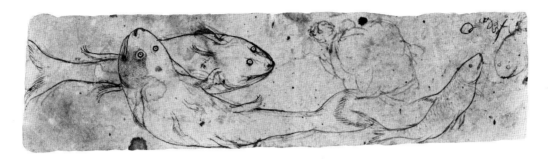

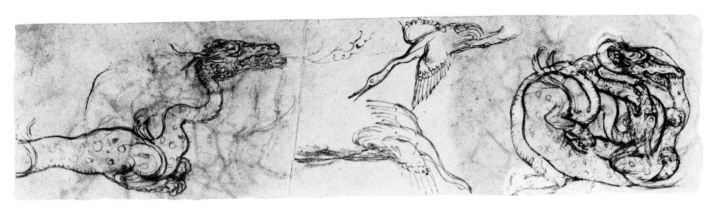

50 *Two Sketches: a. Fish; b. Geese and Dragons*

Rajasthan, Kotah; ca. 1735
Black and red line on paper
a. H. 3.4 cm., W. 13.7 cm.
b. H. 4.6 cm., W. 18.7 cm.
Lent anonymously

Kotah dragons, descendants of Turkman ones (see No. 44), rage and snarl with the same bestial high spirits seen in pictures of tigers and elephants. Two here are as convoluted as pretzels. The geese might have been sketched for a magnificent ceiling painting extant in Kotah fort—a superb arabesque-like design that seems to be a local adaptation of the sixteenth-century Deccani inhabited arabesque included in our exhibition (No. 28). The catch of fish, drawn by the same artist, is of the same ilk caught in the Chambal River at Kotah today.

player, as they sneak up on a family of music-loving antelope. Perhaps they were engaged in trapping this very one. A third drawing by this artist, in the same collection, shows the death throes of several deer and a pair of lions that have been driven into a small, roped enclosure to be shot for sport. At such times, the huntsmen would seem to have become animals and to have accepted their roles in nature's seemingly cruel order.

The two "cloud banks" of brushwork are purely accidental —traces of the artist's pointing his brush as he worked. Although he probably enjoyed making these precursors of Jackson Pollock's art, he would have been astounded at our enthusiasm for them (and probably would have reached into a studio trash bin to hand us others).

51 *A Pet Antelope*

Rajasthan, Kotah; ca. 1735
Black line and color on paper
H. 13.4 cm., W. 13.4 cm.
Lent anonymously

In Kotah pictures the approach to animals is essentially sympathetic. While the Maharaos devoted a good measure of their energy and intelligence to hunting them down and killing them, they also loved them. Here the artist feelingly emphasizes the antelope's tenderness. Another drawing by the same hand from the same collection shows Maharao Durjan Sal on the horizon, watching huntsmen in the foreground concealed behind branches of trees and a vina

52 *Four Views of a Playful Elephant*

Rajasthan, Kotah; ca. 1745
Black line with gold and color on paper
H. 15.4 cm., W. 21.4 cm. (sight)
Lent anonymously

A brave or foolhardy youth cavorted with a baby elephant, tempting it with sweets, and one of the Kotah artists sketched the scene, carrying the work further than usual by adding paint. In India such scenes are now rare. Gradually, elephants have been passed by as impractical and decidedly uneconomical. The first Mughal emperor, Babur, pointed out their weakness as implements of war by terrifying his enemy's elephant corps with cannon at Panipat. By the middle of the eighteenth century artillery was common and elephants were used only as ambulatory watchtowers from which generals could survey the battlefield. Later, these appealing, noble creatures, who are said to have poor eyesight but subtle senses of smell and hearing, became pack animals —or symbols of power to be used in parades. Now the once

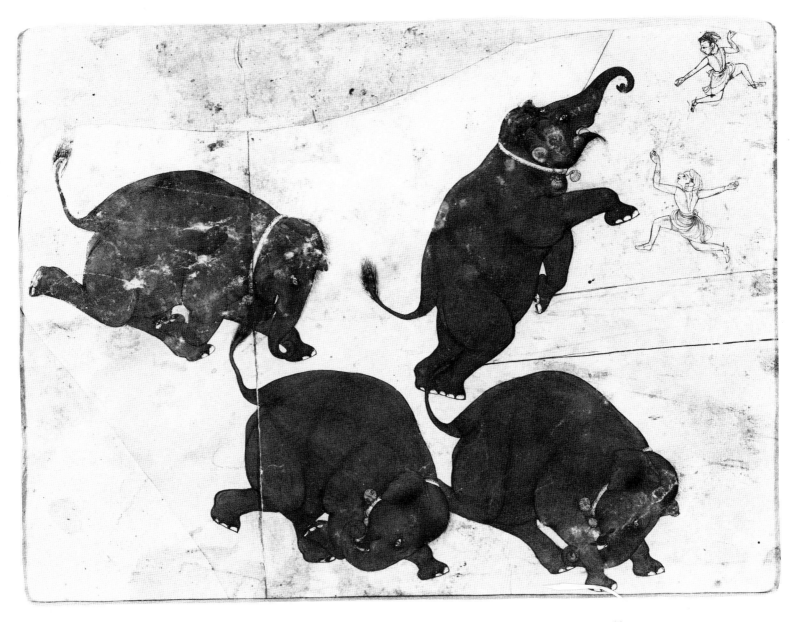

royal elephant can be hired for anyone's wedding procession, or by tourists who can bob about on one for a half hour and pay less than the price of a short taxi ride in Paris, New York, or London.

This drawing is by another anonymous Kotah painter deserving of posthumous acclaim. He may have been apprenticed to the "Master of the Elephants," whose hand can be identified in works dating well into the eighteenth century.

That he knew the earlier artist's work is suggested by a copy ascribable to him of the Master's well-known picture of Ram Singh pursuing a rhinoceros (see: Beach, *Rajput Painting at Bundi and Kota,* fig. 73). Here, however, he drew from life and the results are strikingly immediate.

For other pictures that appear to be by the same artist, see: Welch, *A Flower from Every Meadow,* no. 22, and Pramod Chandra, *Bundi Painting* (New Delhi, 1959), pls. 6, 8.

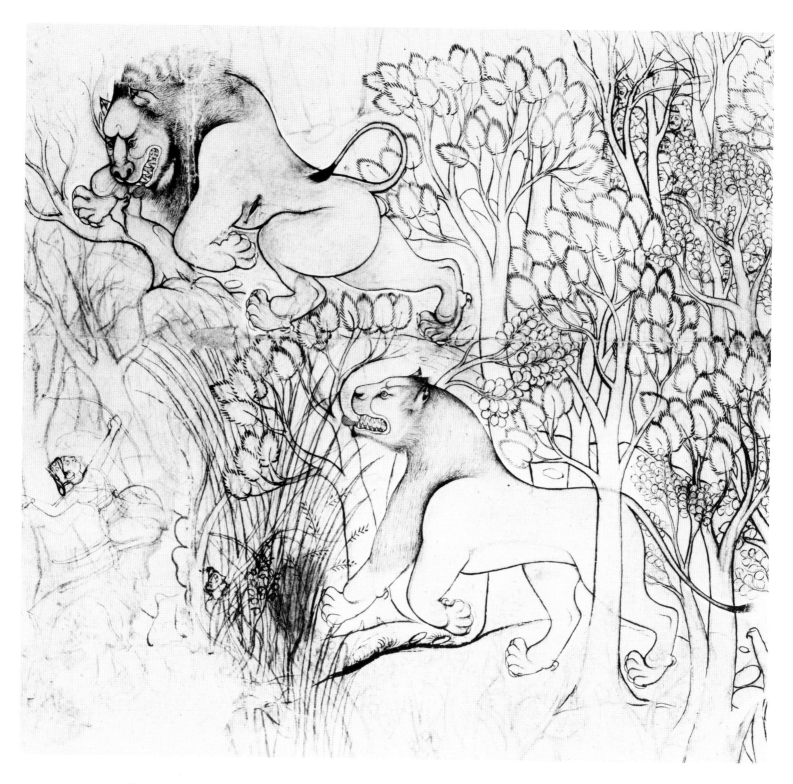

53 *Lion Hunt*

Rajasthan, Kotah; ca. 1745
Black line with slight color on paper
H. 49.5 cm., W. 53.5 cm.
Lent anonymously

Along with the ordering of elephant combats, hunting lions was an imperial Mughal prerogative that was rigidly enforced. Lions were not only the kings of the jungle, they were also ancient symbols of chaos and evil; and only kings —gods on earth—were their appropriate human counterparts. Considerable impunity was required, therefore, when the Kotah rulers enjoyed these sports; and it may have been a clever ruse when paintings of them were inscribed as showing long dead princes poaching on the royal game. As we know of Maharao Durjan Sal's taste for such activities, we may suppose that he was actually the hero of this painted victory over the four-legged, royal personifications of badness.

At Kotah, certain themes were repeated by artists of several generations. This unfinished sketch is in fact later than an elaborately detailed version that purports to show Bhoj Singh of Bundi (r. 1588–1607) in the midst of the hunt (see: Welch and Beach, *Gods, Thrones, and Peacocks,* no. 31). While the earlier artist emphasized the lion's fur and the feathery texture of the leaves, this one concentrates upon the animal's sleek power. The drawing marks a transition from the linearism of Kotah pictures before 1760 (which might all be classed as tinted drawings) to the coloristic sort of the later eighteenth century (for examples, see: Beach, *Rajput Painting at Bundi and Kota,* nos. 129, 130, 131).

54 *Three Moods*

Rajasthan, Kotah; ca. 1845
Black and red line with slight color on paper
H. 20.8 cm., W. 20.2 cm.
Lent anonymously

The last great patron of painting at Kotah was Ram Singh II (r. 1828–66) whose artists drew as constantly as their predecessors. This page of sketches appears to have progressed from the somewhat mechanical religious image (top right) to livelier matters, when a woman attracted the artist's attention. At first (lower right) she pleased the draftsman, who sketched her smiling appealingly. But she was not happy to be a model, and made a straight-armed gesture (upper left) that internationally means "Stop!" He refused. Instead, he replied with a fierce likeness (lower left) in which she is not only scowlingly nasty, but coarse and slovenly. The artist had the last word, and we still hear it!

55 *A British Officer*

Rajasthan, Kotah (?); ca. 1850
Black line and slight color on paper
H. 13.7 cm., w. 13.8 cm.
Lent anonymously

Bright-eyed, thin-lipped, and mutton-chopped, this military
gentleman exudes efficiency and confidence, with just enough
humanity to be sympathetic. The Indian artist, probably
from Kotah, must have liked and respected him. With con-
suming deliberation, he recorded the depth of each wrinkle
and the texture of each patch of hair. In his eagerness, he
nearly gouged through the paper to bring out the high-
ridged nose, cavernous nostrils, and hollowed eye sockets—
efforts that resulted in a memorable recreation of a hardy
Victorian. In its honesty, the picture reminds us of Giotto's
works or the preparatory studies from life that Lucas
Cranach made as guides for his usually less convincing
painted portraits.

In the mid-nineteenth century, British residents, ordinarily
equipped with military aides, lived at most of the Rajput
courts. Their roles no doubt varied over the years and from
court to court, but their responsibilities ranged from tax
collecting to being the eyes and ears of the British Raj or
simply keeping the peace. Often they were on friendly terms
with the Rajput chiefs and their families, though each must
have found the other's ways exotic, frequently comical, and
occasionally repulsive. Relations between them could only
have been ambiguous and at times strained. Who was master
—the Raja or the resident? While the costumes were extrav-
agantly jeweled and plumed, no one can have been quite
sure whether they were being worn in a comic opera, a
drawing room comedy, or a tragedy.

56　*White Horse*

Rajasthan, Kotah; mid-19th century
Black line and slight color on paper
H. 20 cm., W. 23.5 cm.
Inscribed: "Sirga," perhaps the name of the horse
Lent anonymously

If this tinted drawing were seen out of context, we might suspect it to be an English work, perhaps even by Stubbs, the great animal painter. It can be linked, however, with other drawings and paintings done in the British manner at Kotah, where mid-nineteenth-century artists were well aware of the English school. Naturalistic even to catching the velvety texture of the horse's muzzle and the haphazard braiding of the mane, this picture may have been commissioned as a true-to-life portrait of a horse that was bought or sold by the Rao. A companion to it is in the collection of Mr. Philip Hofer.

57 *A Floozy*

Rajasthan, Kotah; mid-19th century
Black line and color on paper
H. 13.5 cm., w. 16.5 cm.
Lent anonymously

A spiritual descendant of "The Vamp" (No. 42), this fancy
lady with hennaed hands and feet smiles brazenly at the artist
and at us. She was sketched in vivid hues by an inspired
draftsman, who frequented the flesh pots at Kotah not long
before Henri de Toulouse-Lautrec did the same in Paris.
Somewhat tipsily, our new friend welcomes us with a flagon
of liqueur—probably of the Rajasthani sort flavored with
saffron and other spices. Two other bottles and a small cup
await behind her, in case we accept.

Regrettably, the drawing has lost a large corner, perhaps
cut off by the lady's companion, whose hand can be seen on
her shoulder and for whom this work of art may have been
all too candid. In discussing "The Vamp," we commented
upon the significance of profile as compared to frontal por-
traits of women. These distinctions eventually gave way,
due to the influence of British examples, not many years
before the total demise of the Rajput and Mughal schools.

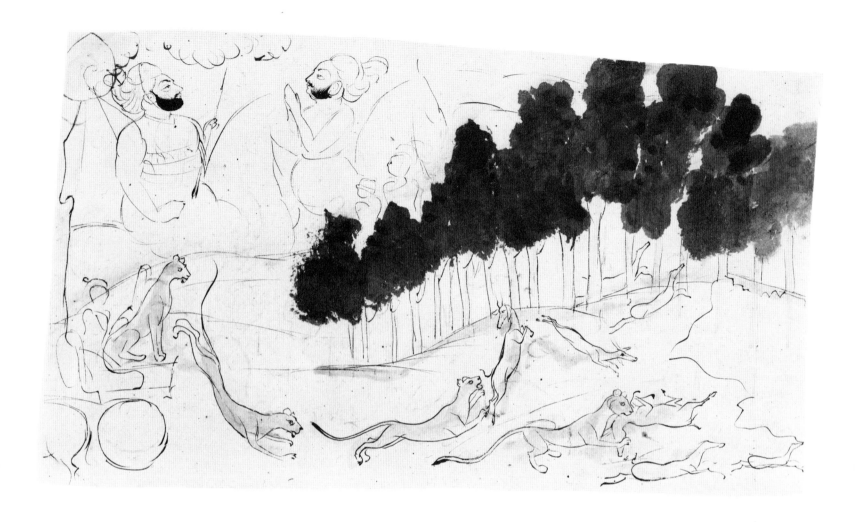

58 *Cheetah Hunting*
Attributed to Bagta
Rajasthan, Devgarh; late 18th century
Black line and color washes on paper
H. 18 cm., W. 31.8 cm.
Lent anonymously

As in a film clip, the hunt is shown here in four stages. At the left the cheetah sits with dignity on his wagon; next he has sighted the deer and jumps to the ground; after that he leaps forward, claws menacing; and finally he grasps his quarry and sinks his teeth into its neck. A "procession" of trees behind him echoes and reinforces the bounding action.

This dashingly fluid sketch is from Devgarh, a modest but unusually appealing school of painting, somewhat akin in spirit to Kotah. During the second half of the eighteenth century and in the early nineteenth, a small succession of excellent artists worked for the Rawats of Devgarh, who were noted for their great size and their prowess in the hunting field. One of them, Rawat Gokul Das (r. 1786–1821), is shown in the background of the sketch, holding an arrow while being congratulated by an attendant. On the basis of style this painting can be attributed to Bagta, who painted some of the most exciting hunting pictures in Rajput art.

See: Milo Cleveland Beach, "Painting at Devgarh," *Archives of Asian Art* 24 (1970–71), pp. 23–35.

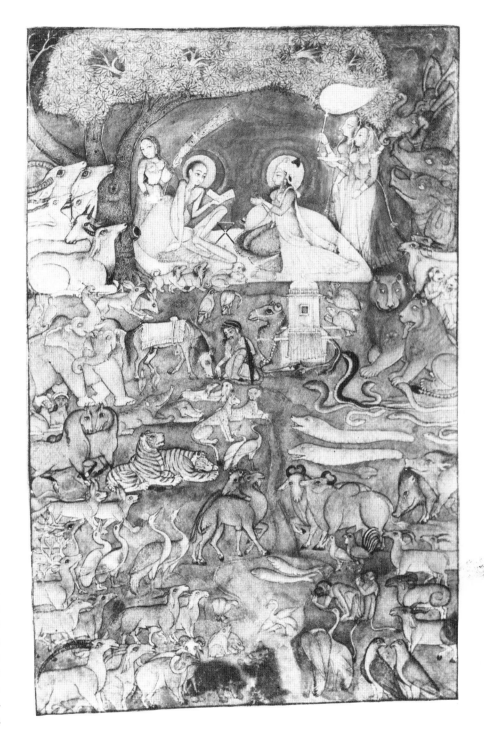

59 *Layla and Majnun*
By Chokha
Rajasthan, Devgarh; ca. 1810
Black line with wash, gold, and color on paper
H. 29.2 cm., W. 19 cm.
Lent by the Jagdish and Kamla Mittal
Museum of Indian Art

From the late eighteenth century, when the Devgarh school of painting first emerged, to the mid-nineteenth, when it ended, only a few artists were employed at a time. Although there was a marked Devgarh style, each of its practitioners displayed strongly personal variants. One of these artists was Chokha, whose world at times seems to have been made up of stuffed animals. A hard worker, whose "primitive" idiom recalls another excellent painter, the Douanier Rousseau, Chokha spent long days and nights elaborating his compositions with delightful intricacies. A Chokha battle scene is so mobbed with tiny horses, men, and elephants that at a distance it looks like spilled tacks. Here he seems to have combined the themes of Layla and Majnun, the tragically frustrated lovers, with the traditional subject of King Solomon, who is usually given a court of birds and beasts, mythological and real. Lions, tigers, fish out of water, and sphinxes are all blissfully paired off. As interpreted by the always amiable Chokha, even emaciated Majnun seems content.

60 *Krishna*

Rajasthan, Jaipur; ca. 1800
Black line with color washes and touches of
white on paper
H. 66.6 cm., W. 46.1 cm.
Lent by The Metropolitan Museum of Art;
Rogers Fund, 1918

A justly famous picture, this tinted drawing was made as a cartoon for a wall painting in the library of Maharaja Pratap Singh (r. 1779–1803) in the City Palace of Jaipur. Perhaps because it represents Lord Krishna, the central figure in the Ras Lila (dance of the god with the *gopis*, or cowgirls), it was carried farther than any of the other sketches in the series. The artist's description of Krishna's unearthly beauty would seem to have been inspired by a beautiful girl, perhaps one who danced as the god at the Jaipur court.[1] True to traditional Indian canons of beauty, his eye is like a pipal leaf, his eyebrow like a tensed bow, and his locks of hair undulate like graceful serpents.

Large in size and superb in execution, this drawing is almost essential to any major exhibition of Indian art. For the second time it is included in an Asia House exhibition.

First published by A. K. Coomaraswamy in *Rajput Painting* (London, 1916), pl. IX, the drawing has been reproduced in numerous publications including Lee, *Rajput Painting,* no. 49.

1. For examples of beautiful women dancing the role of the love god, see: Chandra, *The World of Courtesans*.

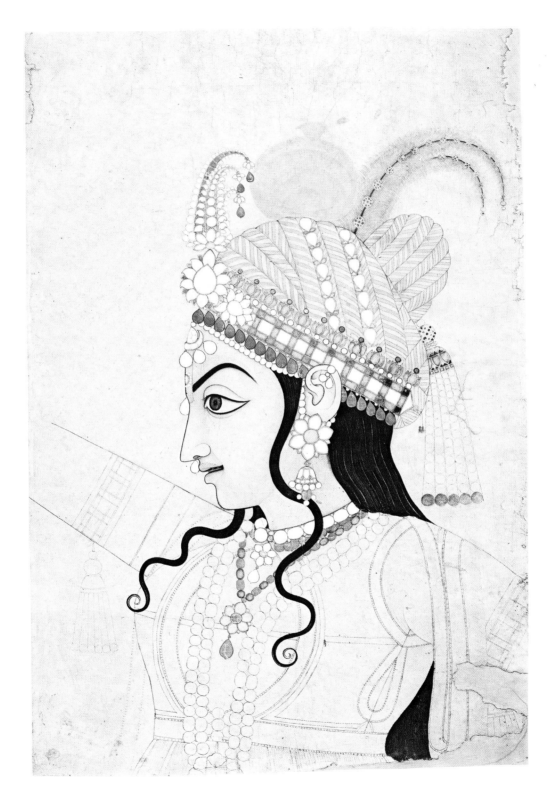

109

61 *Two Musicians*

Rajasthan, Jaipur; ca. 1800
Black line on paper
H. 66.1 cm., W. 45.7 cm. (sight)
Lent by The Metropolitan Museum of Art;
Rogers Fund, 1918

Although it resembles an Assyrian relief as rendered by Flexner, the British neo-classical artist, this drawing is another cartoon for Pratap Singh's library in the City Palace of Jaipur. The drawing is formally perfect in its even outlines, with arcs of mathematical precision, but the singer and the *sarangi* player nevertheless are sparked with life—despite the unnatural metaphors of eyes, eyebrows, and flower-like hands.

Notwithstanding their appeal and their survival in profusion, pictures of the school of Jaipur and the earlier capital, Amber, have been largely neglected by art historians. The fort at Amber was the center of the Kachhwaha Rajputs before Sawai Jai Singh (r. 1693–1743) founded Jaipur in about 1700.

Published: Coomaraswamy, *Indian Drawings,* vol. 2, p. 21, pl. I; A. H. Fox Shangways, *The Music of Hindostan* (Oxford, 1914), pl. 5.

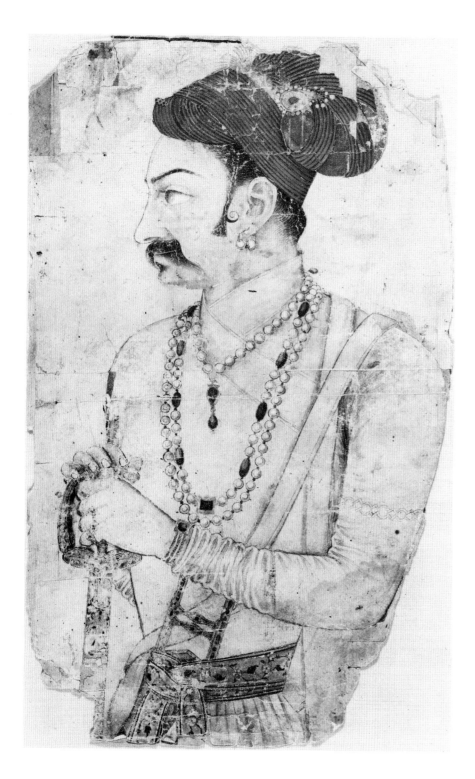

62 *Raja Karan Singh of Bikaner*

Rajasthan, Bikaner; ca. 1655
Black line with gold and color on paper
H. 28.2 cm., W. 17.2 cm.
Lent anonymously

Raja Karan Singh (r. 1631–1669/74) holds a Deccani sword, perhaps one he captured during service with the Mughals. Like that of so many Rajput princes, his career was closely linked to the imperial house and for his bravery in the Mughal cause, he was made governor of Daulatabad. Later, because he supported the cause of Dara Shikoh (see Nos. 20, 21), he was deprived of his *mansab* (post) by Aurangzeb, who gave it to Karan's son, Anup Singh (r. 1675/78–98). The latter was the only survivor among four sons. Of the others, two were slain fighting for the Mughals at the siege of Bijapur; the third died in a tragedy at the imperial camp, a duel over a pet fawn.

This fragmentary portrait bears the scars of too much admiration. Once worn out, it was pricked along the outlines so that a replacement could be made, presumably the version now in the collection of Sri Motichand Khajanchi of Bikaner. Among Rajput portraits this one stands out for its dignity, liveliness of characterization, and boldness of scale.

For Bikaner painting see: Goetz, *The Art and Architecture of Bikaner State.* See also: Karni Singh, *The Relations of the House of Bikaner with the Central Powers* (New Delhi, 1974).

For the Khajanchi version, see: Karl Khandalavala, Moti Chandra, and Pramod Chandra, *Miniature Paintings from the Sri Motichand Khajanchi Collection* (New Delhi, 1960), no. 85, fig. 66.

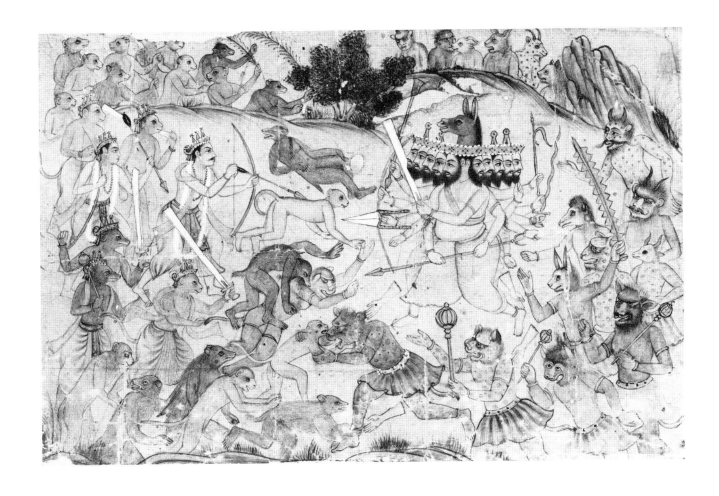

63 *The Fray Begins*

Rajasthan, Bikaner; ca. 1680
Black line with color washes and touches of white
on paper
H. 10.4 cm., W. 15.8 cm.
Lent by Mr. Edwin Binney, 3rd

Probably from a series of illustrations to the Hindu epic, the *Ramayana,* this picture shows Rama readying an arrow to shoot at the many-headed villain, Ravanna, each of whose faces has a slightly different expression. Behind Rama, his younger brother Lakshman, with his bow still over his shoulder, surveys the action. Round about, Ravanna's fellow demons engage Rama's army of bears and monkeys. In the end, Rama defeated the arch-villain at the fort of Lankha and freed his beloved Sita, whose abduction by Ravanna had set all this in motion.

The landscape and figures of this busy composition are characteristic of Bikaner art during the reign of Anup Singh. Ravanna's, Rama's, and Lakshman's profiles remind us of the pictures made in the Deccan at Aurangabad, the provincial Mughal capital (see No. 37).

64 *Raja Jaswant Singh in Darbar*

Rajasthan, Jodpur; ca. 1645
Black line with gold and white on paper
H. 16.5 cm., w. 21.5 cm. (sight)
Lent by the Victoria & Albert Museum

Rulers with their courts, when deployed as for a group photograph nowadays, are known as *darbars*. The earliest picture of a *darbar* known to the author is an Iranian portrait presumed to be of the Turkman Sultan Yaqub Beg of Tabriz (see: Stuart Cary Welch, *A King's Book of Kings* [New York, 1972], fig. 3). Although few other Iranian examples are known, the theme became extremely popular at the Mughal court and spread from there to the Rajputs. Markedly Mughal in style, this formal portrait shows Raja Jaswant Singh of Marwar (r. 1635[?]–78). With its stark isolation of the figures, the drawing interprets the prince and his court as symbols of authority rather than as living individuals.

Raja Jaswant Singh's long reign was productive and peaceful, on the whole. It was marred, however, by a terrible event in which vast numbers of Rajputs were slain, due, at least in part, to Raja Jaswant's faulty judgment. In 1657 he was in charge of Dara Shikoh's united forces at the battle of Dharmat, fifteen miles from Ujjain. Instead of attacking the two opposing armies of Aurangzeb and Murad Bakhsh one by one, he waited until they had both assembled, in the vainglorious belief that it was better to defeat two princes at once. In this battle, six Kotah princes were left on the field and only one survived. Had it not been for this defeat, Aurangzeb might not have overwhelmed Dara Shikoh the second time, at Samugarh (see No. 21), and the course of Mughal history might have been quite different.[1] When Jaswant Singh returned to his fort at Jodhpur, his wife was so distressed at his having left the field alive, when so many Rajputs had died for the cause, that she locked the gates against him.

1. For an interesting speculation of what might have happened had Dara Shikoh become emperor, see: Gulammohammed Refai, "Aurangzib and Dara Shukoh," *Essays in Indian History*, ed. Donovan Williams and E. Daniel Potts (New Delhi, 1973), pp. 137–51.

65 *Stout Warrior*

Rajasthan, Kishangarh; ca. 1735–40
Black line with color and white on paper
H. 22.5 cm., W. 18.4 cm. (sight)
Lent anonymously

Seated on a *takt* (throne) and corseted by a wide sash, this stout Rajput looks haughtily into space while puffing on a water pipe. Before him, a tiny cup contrasts with his bulk, while the longest *katar* we have ever seen bristles in his belt.

Although we cannot identify this military figure, his oddly tied turban is of a sort illustrated in early eighteenth-century Kishangarh paintings and the sitter himself would seem to be from there. One wonders if he ever saw this portrait, which is so close to caricature that we suspect it was drawn as a private joke between the artist and the patron, presumably the Maharaja of Kishangarh, Sawant Singh (r. 1719–57).

Although Kishangarh painting owes a great deal to Mughal court art, perhaps as a result of Maharaja Sawant Singh's sojourn at the court of Muhammad Shah (with whom he shared an intense interest in music and poetry), this Rajput school brought several new elements to the style. One of these was a more conspicuous sense of humor, as is revealed here.

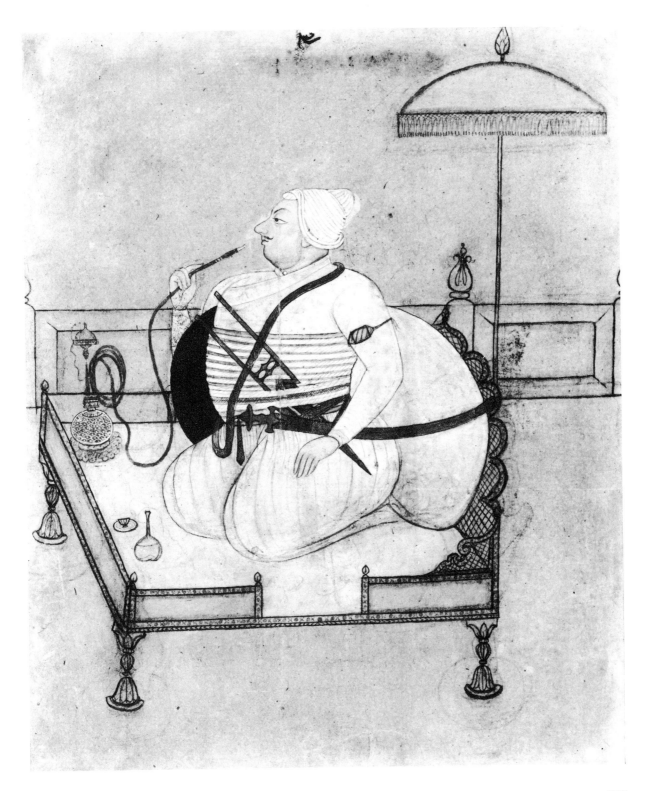

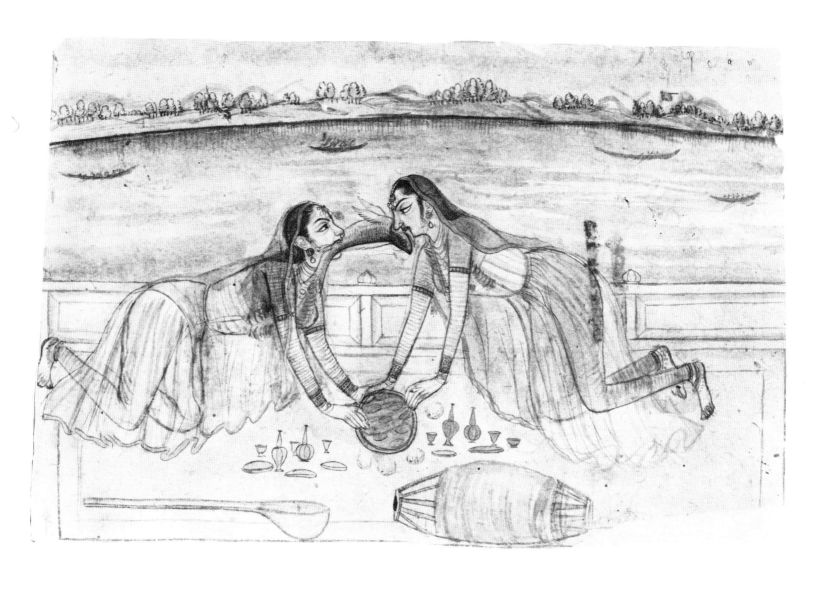

66 *Strange Happenings on a Terrace*
Rajasthan, Kishangarh; ca. 1740
Black line with gold and color washes on paper
H. 12.6 cm., W. 19.9 cm.
Lent anonymously

While conventional *darbars*, devotional pictures of Krishna and Radha, and flower studies were painted with distinction at Kishangarh, the most striking representations tend to be the mysterious and unique ones, such as this drawing in which two musicians bite into a flying fish. Did it accidentally leap into their mouths? Or is this weird episode a surrealistic invention of the poet-prince, Sawant Singh? An inspired patron of painting, he retired in 1757 to concentrate on religious verse dedicated to Krishna.

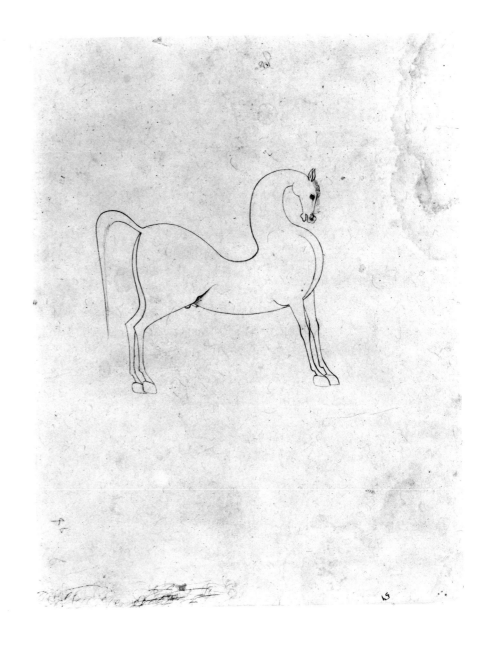

67 *Stallion*

Rajasthan, Kishangarh; ca. 1745
Black line on paper
H. 28.3 cm., W. 20.3 cm.
Lent anonymously

Swaybacked horses—equine equivalents of improbable hy-
brid flowers—seem, on the basis of paintings that have sur-
vived, to have been a speciality of Kishangarh, where so
many "normal" elements of day-to-day life were trans-
formed into outlandish wonders. In this masterfully simple
line drawing a stallion becomes a cross between a swan and
a pouter pigeon but, as in other extreme pictures from this
court, the visualization is so bizarre that we accept it.

68 *Krishna and Radha*

Attributed to Nihal Chand
Rajasthan, Kishangarh; ca. 1750
Black line on paper
H. 27.1 cm., W. 32 cm.
Lent anonymously

Even before the reign of Sawant Singh, Kishangarh was a center of Vaishnavite worship. A high percentage of surviving pictures from this school are devoted to the lives of Krishna and his beloved Radha, who are represented in various degrees of courtly mannerism. Elongated leaf-shaped eyes are the school's renowned feature (see cover of Welch and Beach, *Gods, Thrones and Peacocks*). In this picture the god and goddess and their attendants, arranged on a broad terrace overlooking the lake at Kishangarh, are, as usual, lean and elegant to the point of disembodiment. The small figures, gondola-like boats, and fireworks are strangely parallel to elements in contemporary Venetian pictures.

This drawing can be attributed to Nihal Chand, Sawant Singh's best known painter. Several works by him, some signed, have been published by Eric Dickinson and Karl Khandalavala in their fascinating study of this school of painting, *Kishangarh Painting* (New Delhi, 1959). (Note particularly pls. I, IX).

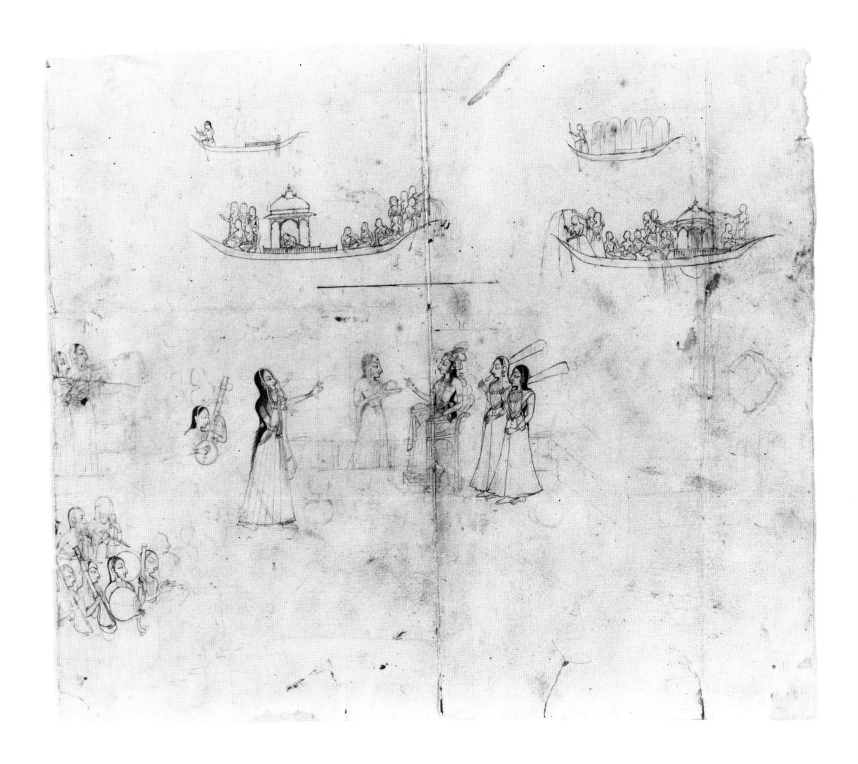

69 *Chaitanya at Bhakti*

Rajasthan, Kishangarh; ca. 1750
Black line over white on tan paper
H. 23 cm., W. 32.5 cm.
Lent by the National Museum, New Delhi

Chaitanya was a Vaishnavite saint from Bengal who lived
from 1485 to 1533. Born a Brahmin, he renounced the secu-
lar world at twenty-four, and spent much of his life traveling
in Orissa, in the Deccan, to Gaur, and to Brindaban—the
place most sacred to Krishna. God-intoxicated, he was one
of the holy men who developed the practice of bhakti, per-
sonal devotion to God of so emotional a character as to be
akin to conjugal love. Often, as here, Chaitanya's sacred
dance led to ecstatic tears.

Inasmuch as Kishangarh was a center for the worship of
Krishna, it is not surprising that this picture was done there,
presumably for Raja Sawant Singh. One can assume that
the drawing is an accurate portrayal of bhakti at the Rajas-
thani court. The simple outlines are placed against sweep-
ingly brushed areas of white that lend a mystical atmosphere
to the picture, as though they were massed auras extending
from the spiritually elevated celebrants.

See: R. C. Majumdar, *The History of Bengal* (Patna, 1971); and Edward C.
Dimock, Jr., "Doctrine and Practice Among the Vaishnavas of Bengal,"
Krishna: Myths, Rites, and Attitudes, ed. Milton Singer (Honolulu, 1966).

Rajput Art: Central India

70 *Procession at Datia*
Central India, Datia; late 18th century
Black line and color on paper
H. 44.2 cm., W. 82.4 cm.
Lent anonymously

The Bundela Rajput rulers of Datia gained questionable renown in 1602 when one of them, Raja Bir Singh Deo, murdered Abu'l Fazl, Akbar's close friend who wrote the *Akbarnama*. He acted at the instigation of Prince Salim (later Emperor Jahangir), who rewarded the assassin most lavishly upon his accession to the throne in 1605. The descendants of Bir Singh Deo, who, it must be admitted, was a great

patron of architecture and a highly successful prince, maintained their state until modern times, resisting invasions by both the Jats and the Marathas.

This imposing processional portrait represents Maharaja Shatrujit (r. 1762–1801), who was slain in battle against the Marathas. Apparently a cartoon for a wall painting, this fragment of a larger work, drawn in sections, harks back to more naturalistic Mughal prototypes (such as No. 22). Less

sophisticated in his treatment of space than were the Mughals, the artist nevertheless captivates us by his forceful observation of horses and men and his strong rhythms.

Little has been written about the Datia school. For other examples, see: N. C. Mehta, *Studies in Indian Painting* (Bombay, 1926), pp. 39–45, pls. 14, 15; Ivan Stchoukine, *La peinture indienne* (Paris, 1929), pl. LXXXVII B; Welch, *A Flower from Every Meadow,* no. 16 (probably a portrait of Raja Shatrujit's son and successor, Raja Parichit).

Detail

126

Rajput Art: Punjab Hills

71 *Mother and Children*
 Punjab Hills, Chamba; ca. 1720
 Black line on tan paper
 H. 20.6 cm., W. 16.5 cm.
 Lent by the Jagdish and Kamla Mittal
 Museum of Indian Art

The artist who drew this spare composition must have felt tenderly about family pleasures. Against a background of ornamental flowers, resembling guides for an embroiderer or weaver, he has caught his wife (?) and children at play. The older boy whacks a ball with a mallet, while the younger child is tossed overhead in a delightfully balanced gesture that combines fun with motherly concern. Such sketches from life can be seen as pleasurable exercises by the artists, who later incorporated some of them into more formal pictures. One imagines that this lyrical, intimate scene might have found a place in a painting about the childhood of Krishna and his brother.

Inasmuch as the Punjab Hills were less accessible to the Mughals than was Rajasthan, the imperial mode was less influential at the Hill courts, many of which retained power-fully expressive art styles until 1700 or even later. In its close observation of nature, this drawing shows Mughal influence, but the stylized eyes and profile, as well as the spirit are traditionally of the Hills. The mountains themselves are implied in such pictures, which evoke untouched freshness, purity of air, altitude, and stillness. It is no wonder that holy men go to the hills where it seems easier to sense godly calm. Quite literally, the artists and patrons of the Hills were "above it all." Writers on Hill painting have tended to wax poetic—unavoidably. In this drawing the swiftly yet unhurriedly, perfectly sketched lines seduce us into sentimental nostalgia, recalling folk tunes played on a flute at sunrise near Dalhousie.

For the fullest treatment of Pahari painting, see: W. G. Archer, *Indian Paintings from the Punjab Hills* (London, 1973).

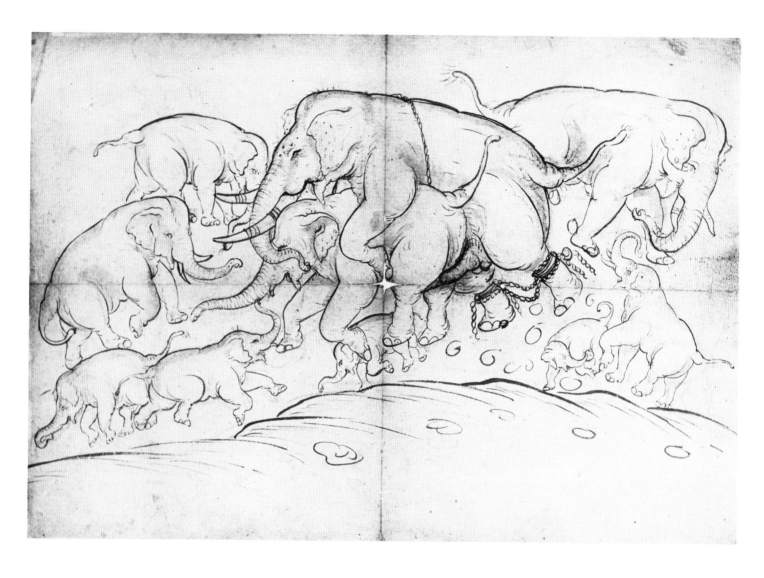

72 *The Bull Elephant's Return from Captivity*
Punjab Hills, Chamba; ca. 1720
Black line with wash on tan paper
H. 22.9 cm., w. 33 cm.
Lent by the Jagdish and Kamla Mittal
Museum of Indian Art

A family of elephants rolls like a wave, perpetuating itself. They become an emblem of the animal world, delighting us with their playfulness, impressing us with their mountain-like size and gentle but awesome energy. The artist, amused and sensitive, has recorded a rare moment for elephant watchers. Apparently a recently captured bull has broken his chains and lovingly rejoined his delighted herd.

Like Kotah in Rajasthan, Chamba was a center of drawing. Thanks to fate, many have been preserved and from them the development of the school can be charted from the seventeenth century onward. The best of these drawings are in the Mittal Museum of Indian Art.

73 *Drunken Musicians*

Punjab Hills, Chamba; ca. 1730
Black line with color washes on paper
H. 44.6 cm., w. 62.2 cm.
Inscribed: (*upper left*) "This is a picture of
drunkards."
Lent by the Jagdish and Kamla Mittal
Museum of Indian Art

Indian caricatures are seldom vicious; their artists concentrate instead on being psychologically revealing and funny. This is one of several similarly outrageous paintings and drawings from the Hills in which the artists twisted and pulled the human body like taffy. Intriguingly, the artist reverted here to the "primitive" style of Hill painting, which shares angular, unnaturalistic forms with the Basohli idiom as we know it from the late seventeenth century. Although the musicians might have preferred anonymity, each has been carefully identified by an inscription above his head.

For a companion drawing in the collection of Karl Khandalavala, Poona, see his *Pahari Miniature Painting* (Bombay, 1958), fig. 7. See also: S. N. Gupta, *Catalogue of Paintings in the Central Museum, Lahore* (Calcutta, 1922), pl. XI.

130

74 *A Raja Entertained by Musicians and Dancers*
Punjab Hills, Chamba (?); ca. 1785–90
Black line with touches of white and color on paper
H. 23.8 cm., W. 29.7 cm.
Lent by Mr. Edwin Binney, 3rd

Parties such as this were one of the highly civilized pleasures of Rajput life. Just as many of the princes maintained artists, so did they employ musicians, dancers, and singers, whose ephemeral arts must have been equally marvelous. Thanks to the artist who sketched this recital, we can at least see one of these happenings and sense the atmosphere. To the right of the Raja, slightly behind two other spectators whom he jotted down, the artist recorded the musicians in the frenzy of creation. Their faces grimace with the contortions still common to Indian musicians. The singing or dancing girls are shown just before or after their performances.

Another version of this drawing is in the Central Museum, Lahore (Gupta, *Catalogue of Paintings,* pl. XIV). Finer in line but lacking in immediacy, it is probably a refined copy of this one. When it was exhibited in London in 1947, the Raja was said to resemble Sansar Chand of Kangra (r. 1776–1824). Although this drawing and that in Lahore would seem to be closely related in style to the Nala-Damayanti series from Kangra (see No. 77), we disagree with the identification of the patron. He seems more like Raja Raj Singh of Chamba, before he grew a full beard. Perhaps the artist later went to Kangra and worked on the Nala-Damayanti set.

See: Archer, *Indian Paintings from the Punjab Hills,* vol. 2, "Chamba" pl. 42, for a drawing of Raj Singh that appears to be by the same hand as the Binney and Lahore sketches.

Detail

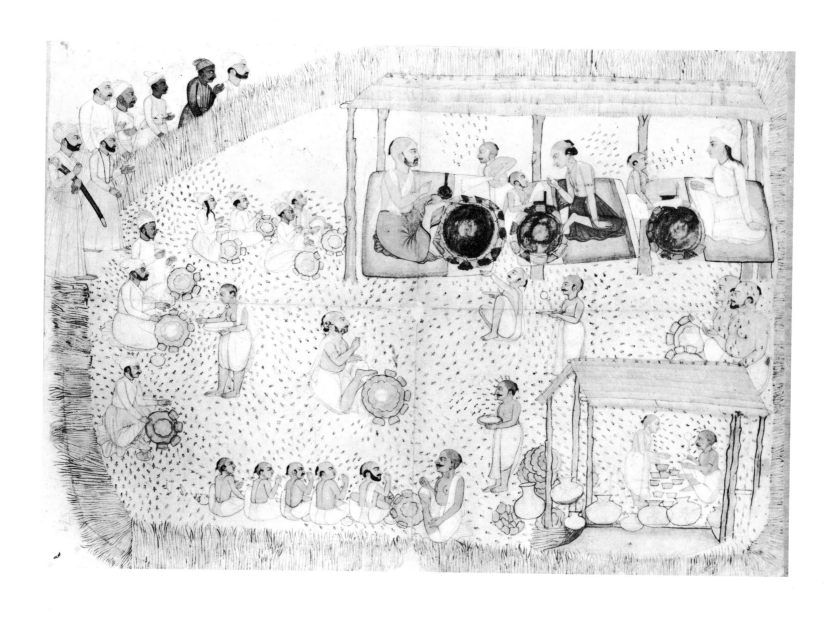

75 *Factory at Work*

Punjab Hills, Jammu or Chamba; ca. 1740
Black line with color washes on paper
H. 41 cm., W. 59 cm.
Lent anonymously

Sometimes Indian pictures, however clearly drawn, baffle us as to what they represent. In this one, a large number of men are extremely busy preparing something involving many large and small pots. Outside their fenced-in compound, a group of distinguished visitors, one of whom carries a sword, looks on reverently. Disturbingly, insects swarm about while the men work, apparently not bothering them greatly. We suspect that these bugs have been attracted to whatever the men are making, which is probably *attar*, the oil-based Indian perfume that comes in many spicily

delicious scents. The perfumes are made according to ancient recipes, some of them from such unlikely substances as the spring dew, gathered at a special time of year from the webbing of a *charpoi* (bed) piled with earth. Others are concocted from various flowers, spices, and musk. Connoisseurs particularly enjoy attars that have mellowed (as well as darkened and greatly thickened) over the years, at best for a century or so. Perfumes are employed for religious rites as well as for pleasure.

Large, secular drawings of this sort from the Hills are extremely rare. While this one owes much to Mughal naturalism, the figure drawing, especially of such details as the eyes, retains elements of the style associated with the school of Basohli in the late seventeenth century.

76 *A Raja Slashing a Fish*
Attributed to Nainsukh
Punjab Hills, Jammu; ca. 1750
Black line with color washes on paper
H. 20.3 cm., W. 27 cm.
Lent by the Jagdish and Kamla Mittal
Museum of Indian Art

At times the mystery of Indian pictures is increased by our own ignorance. What might to the initiated be a straightforward act seems to us peculiar and fascinating. Why, for instance, is this intent, bearded Raja (?) attacking a large fish with his *tulwar* (sword) in front of an amused and attentive

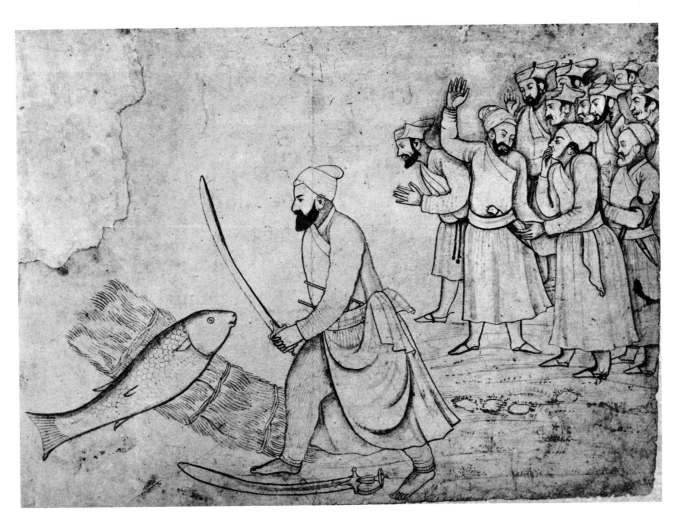

133

crowd of observers? The comments of an early nineteenth-century writer suggest a plausible explanation: "At their sword exercise, they practice 'the stroke' on the hide of a buffalo, or on a fish called roory, the scales of which form an excellent coat of mail, each being the size of a crown-piece, and the substance sufficient to turn the edge of a good sabre."[1]

The drawing is strikingly close to Nainsukh's signed

works and can be attributed to him. The expressive characterizations, linear qualities, spirit, and such minor details as the penchant for striped trousers are all consistent with his artistic personality.

For a detailed study of Nainsukh, see: Archer, *Indian Paintings from the Punjab Hills,* vol. 1, pp. 194–208.

1. Mrs. Meer Hassan Ali, *Observations on the Mussulmauns of India* (reprint ed., Karachi, 1974), p. 218.

77 *The Toilet of Damayanti*
Punjab Hills, Kangra; 1790–1800
Black line and slight color over white on paper
H. 29.4 cm., W. 39.5 cm.
Lent by The Metropolitan Museum of Art;
Rogers Fund, 1918

One of the most graceful and immediately appealing styles in Indian painting is that of Kangra, where a set of illustrations to the story of Nala and Damayanti was drawn (and in part painted) in the late eighteenth century. This page is from that series. While the style is clearly derived from late Mughal art, the mood is not; gentler and more lyrical, these pictures stand in relation to Mughal ones as Renoir's would to those of Degas. The Kangra style leans towards soft idealization as opposed to Mughal sharp-eyed observation. Mughal people and animals are solidly, at times heavily, planted on earth; Kangra ones float with ethereal lightness.

Here three scenes are represented in continuous narration: at left the lover, Nala, pursues his beloved, Damayanti; in the center she prepares for a tryst, while he—having been given the boon of invisibility by the gods—eavesdrops;

and then, at the right, he departs. In the foreground, a peacock strides behind his hens, symbolizing Krishna and the *gopis* or a prince and his ladies. Intriguingly, the characterization of Nala seems very similar to that of the prince in "A Raja Entertained" (No. 74)—further evidence for our belief that the creator of the Binney drawing worked on this Kangra set.

Many of the illustrations to this series, perhaps the most subtle and elegant survival from the Kangra school, are in the Museum of Fine Arts, Boston. A study of the entire set was written by Alvan C. Eastman (*The Nala-Damayanti Drawings* [Boston, 1959]).

Published: Coomaraswamy, *Indian Drawings,* vol. 2, p. 23, pl. VIII.

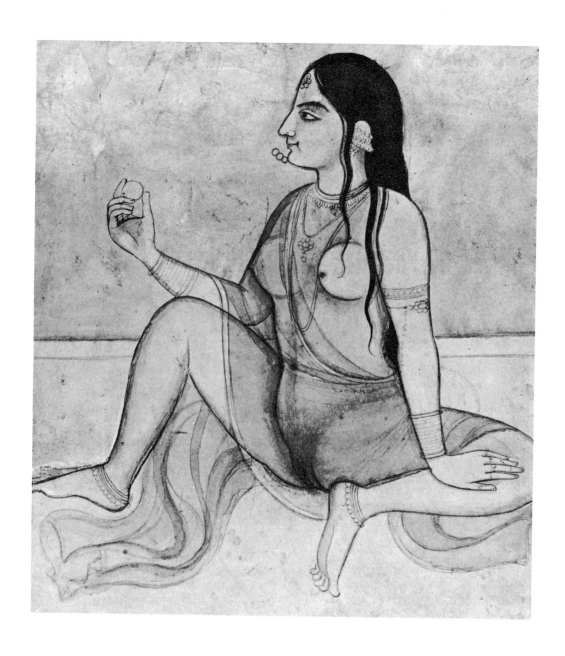

78 *Portrait of a Courtesan*
Punjab Hills, Kangra; ca. 1815
Black line with color washes and accents on paper
H. 15.9 cm., W. 14.5 cm.
Lent by the Jagdish and Kamla Mittal
Museum of Indian Art

Studies of the nude are rare in Indian painting, hence the impact is amplified when one is encountered. The woman in this picture is blatantly seductive, wearing nothing but a transparent shawl and smiling most welcomingly. Perhaps this is a portrait of a Raja's beloved, presumably for his private delectation. Her jewelry shows her to be of considerable distinction, and her beauty is certainly memorable.

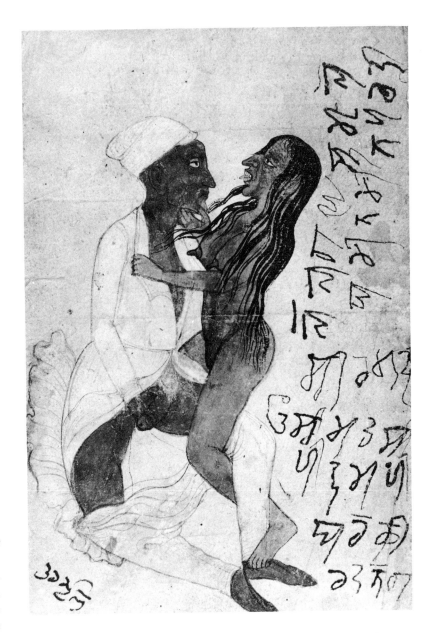

79 *The Seduction of an Old Man*
Punjab Hills, Guler (?); ca. 1745
Black line with washes and touches of red on paper
H. 17.8 cm., W. 12.5 cm.
Inscribed: "Hardayal," perhaps the name of the artist
Lent by the Jagdish and Kamla Mittal
Museum of Indian Art

How dramatic and upsetting! A sad looking old man is being unsuccessfully seduced by a witch! We turn away from the drawing in embarrassment, proving the force of art, fascinated and puzzled as to its meaning. Led by the artist, have we opened a bedroom door at an awkward moment? Or, are we seeing a visitation of Kali, the witch-like goddess of death? The artist confounds us with his bizarre peep show.

Like most traditional Indian painters, he portrays the subject with sensitive objectivity, somehow managing to *be* his subject, like the worshipper who loses himself through meditation and *becomes* his god or goddess. Although the scene of this drawing may have scared the artist, or made him laugh, he sketched it masterfully and accurately, without a trace of intrusive personal comment. As a result, it shocks us as though we came upon the scene live.

Guler painting is most completely discussed by W. G. Archer (*Indian Paintings from the Punjab Hills*), whose illustrations unfortunately include no drawings. "Dancing Villagers" (Archer, "Guler" no. 13) in the Heeramaneck Collection of the Los Angeles County Museum of Art seems to be by the same artist.

80 *Landscape at Amarnath, Kashmir*
 Punjab Hills, Guler; ca. 1830
 Black line and color on paper
 H. 35.6 cm., W. 27.7 cm.
 Lent by the Jagdish and Kamla Mittal
 Museum of Indian Art

William Moorcroft and George Trebeck visited the town of Amarnath, some 13,000 feet above the sea, in the 1820's. We can do no better than to quote their description of this "place of reputed sanctity and pilgrimage," and its cave:

"The road to this cave proceeds from Bhuvan, along the valley of the Lidder to Ganes Bal, so called it is said, from a rude stone figure which is supposed to represent the Hindu deity, Ganesa. It then continues to Pahalgam in Dakshinpara, and thence to the Pesh-bal pass; the latter part of the route is uninhabited. Beyond the pass is the lake of Sesh-nag, nine miles in circumference, and giving rise to a number of rivulets which form the Panch-tarang, or five stream river; another pass in the mountains, the Nezabal, lies beyond this, from which rises the Bhagavati river, flowing into the Panch-tarang. Near this is situated the cave of Amarnath, of which the entrance is said to be one hundred yards broad, and thirty high; the depth of the cave is five hundred yards. There are no inscriptions in it, nor any sculpture; but in the most re-mote part of the cave, there is said to be the figure of a gosein [ascetic], seated on a pedestal, which figure increases and decreases in size with the increasing and waning of the moon, and at the conjunction entirely vanishes. It is customary, therefore, to visit the cave only about the full moon."[1]

Although part of the charm of Mughal and Rajput painting is due to such landscape passages, pure landscape is rare in Indian art, which makes this drawing all the more interesting to specialists. Inspired by British interest in topography as well as Hindu reverence for sacred places, this picture is a convincing view of Amarnath, complete with pilgrims ascending from the town, which includes a map-like representation of a temple and tank. A fully painted version of this picture is in the collection of N. P. Sen, Hyderabad.

1. William Moorcroft and George Trebeck, *Travels in the Himalayan Provinces of Hindustan and the Punjab; in Ladakh and Kashmir; in Peshawar, Kabul, Kunduz, and Bokhara* (London, 1837), vol. 2, pp. 260–61.

Selected Bibliography

Historical works: primary sources

Abu'l Fazl Allami. *Ain-i-Akbari*. Translated by H. Blochmann and H. Jarett. Calcutta, 1875–1948.

———. *Akbarnama*. Translated by H. Blochmann. Calcutta, 1907.

Babur. *The Baburnama in English*. Translated by A. S. Beveridge. London, 1969.

Bernier, F. *Travels in the Mughal Empire (1656–1668)*. Edited by A. Constable. London, 1891.

Hickey, W. *Memoirs of William Hickey*. Edited by A. Spencer. London, 1913–1925.

Jahangir. *The Tuzuk-i-Jahangiri; or Memoirs of Jahangir*. Translated by A. Rogers and edited by H. Beveridge. London, 1909–14.

Manucci, N. *Storia do Mogor*. Edited by W. Irvine. Calcutta, 1966.

Moorcroft, W. and Trebeck, G. *Travels in the Himalayan Provinces of Hindustan and in the Punjab; in Ladakh and Kashmir; in Peshawar, Kabul, Kunduz, and Bokhara*. London, 1837.

Mountnorris, G. A. *Voyages and Travels to India, Ceylon, the Red Sea, Abyssinia, and Egypt in 1802–06*. London, 1809.

Roe, T. *The Embassy of Sir Thomas Roe to India 1615–1619*. Edited by W. Foster. London, 1899.

Tavernier, J. B. *Travels in India*. Edited by W. Crooke. Oxford, 1925.

Tod, J. *The Annals and Antiquities of Rajasthan*. Edited by W. Crooke. London, 1920.

Historical works: secondary sources

Chandra, M. *The World of Courtesans*. New Delhi, 1972.

Cunningham, J. D. *The History of the Sikhs*. Oxford, 1928.

Dimock, E. C., Jr. "Doctrine and Practice Among the Vaisnavas of Bengal." In *Krishna: Myths, Rites, and Attitudes*. Edited by M. Singer. Honolulu, 1966.

Gribble, J. D. B. *A History of the Deccan*. London, 1896–1924.

Gupta, B. "Marathas in the States of Kota and Bundi." *Journal of the Rajasthan Institute of Historical Research* 10 (1973).

Haig, W., ed. *The Cambridge History of India*. Vols. 3, 4, 5. New Delhi, 1958.

Hendley, T. H. *Rulers of India and the Chiefs of Rajputana*. London, 1897.

Irvine, W. *Later Mughals*. Calcutta, 1922.

Majumdar, R. C. *The History of Bengal*. Patna, 1971.

Prasad, I. *The Life and Times of Humayun*. Bombay, 1955.

Quennell, P., ed. *The Prodigal Rake*. New York, 1962.

Refai, G. "Aurangzib and Dara Shukoh." In *Essays in Indian History*. Edited by D. Williams and E. D. Potts. New Delhi, 1973.

Russell, R. and Islam, K. *Ghalib: Life and Letters*. Cambridge, Mass., 1969.

Sarkar, J. *History of Aurangzeb*. Calcutta, 1925.

———. *Fall of the Mughal Empire*. Calcutta, 1949.

Sewell, R. *A Forgotten Empire*. London, 1900.

Shyam, R. *The Kingdom of Ahmadnagar*. New Delhi, 1966.

Singh, K. *The Relations of the House of Bikaner with the Central Powers*. New Delhi, 1974.

Works related to Indian paintings and drawings

Ahmed, N. "Farrukh Husain, the Royal Artist at the Court of Ibrahim 'Adil Shah II." *Islamic Culture* 35 (1956).

Arnold, T. W. *The Library of A. Chester Beatty: A Catalogue of the Indian Miniatures*. Revised and edited by J. V. S. Wilkinson. Oxford, 1936.

Archer, M. *Patna Painting*. London, 1947.

———. *Natural History Drawings in the India Office Library*. London, 1962.

———. *Company Drawings in the India Office Library*. London, 1972.

Archer, M. and W. G. *Indian Painting for the British 1770–1880*. Oxford, 1955.

Archer, W. G. *Kangra Painting*. London, 1952.

———. *Indian Painting in the Punjab Hills*. London, 1953.

———. *Garhwal Painting*. London, 1954.

———. *Indian Miniatures*. New York, 1960.

———. *Painting of the Sikhs*. London, 1967.

———. *Kalighat Paintings*. London, 1971.

———. *Indian Paintings from the Punjab Hills*. London, 1973.

Archer, W. G. and Binney, E. C., 3rd. *Rajput Miniatures from the Collection of Edwin C. Binney, 3rd*. Portland, Ore., 1968.

Archer, W. G. and Czuma, S. *Indian Art from the George P. Bickford Collection*. Cleveland, 1975.

Barrett, D. *Painting of the Deccan, XVI–XVII Century*. London, 1958.

Barrett, D. and Gray, B. *Painting of India*. Lausanne, 1963.

Beach, M. C. "Painting and the Minor Arts." In *The Arts of India and Nepal: The Nasli and Alice Heeramaneck Collection*. Boston, 1966.

———. "Painting at Devgarh." *Archives of Asian Art* 24 (1970–71).

———. *Rajput Painting at Bundi and Kota*. Ascona, 1974.

Binney, E. C., 3rd. *Indian Miniature Painting from the Collection of Edwin Binney, 3rd: The Mughal and Deccani Schools*. Portland, Ore., 1973.

Binyon, L. and Arnold, T. W. *Court Painters of the Grand Moguls*. Oxford, 1921.

Brown, P. *Indian Painting under the Mughals*. Oxford, 1924.

Chandra, M. *The Technique of Mughal Painting*. Lucknow, 1946.

———. *Mewar Painting*. New Delhi, 1957.

Chandra, P. *Bundi Painting*. New Delhi, 1959.

Clarke, C. S. *Indian Drawings: Thirty Mogul Paintings . . .* (Victoria & Albert Museum Portfolios). London, 1922.

Coomaraswamy, A. K. *Indian Drawings*. London, 1910–12.

———. *Rajput Painting*. London, 1916.

———. *Catalogue of the Indian Collections in the Museum of Fine Arts, Boston*. Parts 5 and 6. Cambridge, Mass., 1926–30.

———. "Les miniatures orientales de la collection Goloubew au Museum of Fine Arts de Boston." *Ars Asiatica* 13 (1929).

Dickinson, E. and Khandalavala, K. *Kishangarh Painting*. New Delhi, 1959.

Dickson, M. B. and Welch, S. C. *The Houghton Shahnameh*. Cambridge, Mass., forthcoming.

Doshi, S. "An Illustrated Manuscript from Aurangabad, Dated 1650 A.D." *Lalit Kala* 15 (n.d.).

Eastman, A. C. *The Nala-Damayanti Drawings*. Boston, 1959.

Ebeling, K. *Ragamala Painting*. Basel, 1973.

Egger, G. *Hamza-Nama I*. Graz, 1974.

Ettinghausen, R. *Paintings of the Sultans and Emperors of India*. New Delhi, 1961.

———. *Great Drawings of All Time*. Edited by I. Moskowitz. Vol. 6. New York, 1962.

Ettinghausen, R. and Binney, E. C., 3rd. *Islamic Art from the Collection of Edwin Binney, 3rd*. Washington, 1966.

Glück, H. *Die Indischen Miniaturen des Hamsae-Romanes*. Vienna, 1925.

Godard, Y. A. "Les marges du murakka Gulshan." *Athar-e Iran* 1 (1936).

———. "Un album des portraits des Princes Timurides de l'Inde." *Athar-e Iran* 2 (1937).

Goetz, H. *The Art and Architecture of Bikaner State*. Oxford, 1950.

Goswamy, B. N. "The Problem of the Artist Nainsukh of Jasrota." *Artibus Asiae* 28 (1966).

———. "Pahari Painting: The Family as the Basis of Style." *Marg* 21 (1968).

Gray, B. "Painting." In *The Art of India and Pakistan*. Edited by L. Ashton. London, 1949.

Gupta, S. N. *Catalogue of Paintings in the Central Museum, Lahore*. Calcutta, 1922.

Khandalavala, K. *Pahari Miniature Painting*. Bombay, 1958.

Khandalavala, K. and Chandra, M. *New Documents of Indian Painting—a Reappraisal*. Bombay, 1969.

Khandalavala, K., Chandra, M., and Chandra, P. *Miniature Paintings from the Sri Motichand Khajanchi Collection*. New Delhi, 1960.

Kramrisch, S. *A Survey of Painting in the Deccan*. London, 1937.

———. *Unknown India: Ritual Art in Tribe and Village*. Philadelphia, 1968.

Krishna, A. *Malwa Painting*. Banares, n.d.

Krishnadasa, R. *Mughal Miniatures*. New Delhi, 1955.

Kühnel, E. and Goetz, H. *Indian Book Painting from Jahangir's Album in the State Library in Berlin*. London, 1926.

Lee, S. *Rajput Painting*. New York, 1960.

Martin, F. R. *The Miniature Paintings and Painters of Persia, India, and Turkey*. London, 1912.

Mittal, J. *Andhra Paintings of the Ramayana*. Hyderabad, 1969.

Pal, P. *Ragamala Paintings in the Museum of Fine Arts, Boston*. Boston, 1967.

Randhawa, M. S. *Basohli Painting*. New Delhi, 1959.

———. *Kangra Paintings of the Bhagavata Purana*. New Delhi, 1960.

———. *Kangra Paintings on Love*. New Delhi, 1962.

———. *Kangra Paintings of the Gita Govinda*. New Delhi, 1963.

———. *Chamba Painting*. New Delhi, 1967.

Sarre, F. and Mittwoch, E. *Die Zeichnungen von Riza 'Abbasi*. Munich, 1914.

Schimmel, A. *Islamic Calligraphy*. Leiden, 1970.

Schroeder, E. "The Troubled Image." In *Art and Thought*. Edited by K. B. Iyer. London, 1947.

Sharma, O. P. *Indian Miniature Painting*. Tokyo, 1973.

Shiveshwarkar, L. *The Pictures of the Chaurapanchasika*. New Delhi, 1967.

Sivaramamurti, C. *South Indian Paintings*. New Delhi, 1968.

Skelton, R. "The Mughal Artist Farrokh Beg." *Ars Orientalis* 2 (1957).

———. "Documents for the Study of Painting at Bijapur." *Arts Asiatiques* 5 (1958).

———. *Indian Miniatures*. Venice, 1961.

Spink, W. *Krishnamandala*. Ann Arbor, Mich., 1971.

Stchoukine, I. *Les miniatures indiennes de l'époque des grands Moghols au Musée du Louvre*. Paris, 1929.

———. *La peinture indienne*. Paris, 1929.

Stooke, H. J. and Khandalavala, K. *The Laud Ragamala Miniatures*. Oxford, 1953.

Strzygowski, J. *Die Indischen Miniaturen im Schlosse Schönbrunn*. Vienna, 1923.

Welch, S. C. "Early Mughal Miniature Paintings from Two Private Collections." *Ars Orientalis* 3 (1959).

———. "The Emperor Akbar's *Khamsa* of Nizami." *The Journal of the Walters Art Gallery* (1959).

———. "The Paintings of Basawan." *Lalit Kala* 10 (1961).

———. *The Art of Mughal India*. New York, 1963.

———. "Mughal and Deccani Miniature Paintings from a Private Collection." *Ars Orientalis* 5 (1963).

Welch, S. C., and Beach, M. C. *Gods, Thrones, and Peacocks*. New York, 1965.

Welch, S. C. and Bearce, G. D. *Painting in British India, 1757–1857*. Brunswick, Maine, 1963.

Welch, S. C. and Zebrowski, M. *A Flower from Every Meadow*. New York, 1964.

Wellesz, E. *Akbar's Religious Thought Reflected in Mogul Painting*. London, 1952.

Wilkinson, J. V. S. *The Lights of Canopus*. London, 1929.